Randy Loubier

An Extraordinary Journey
From Accountant to Artist

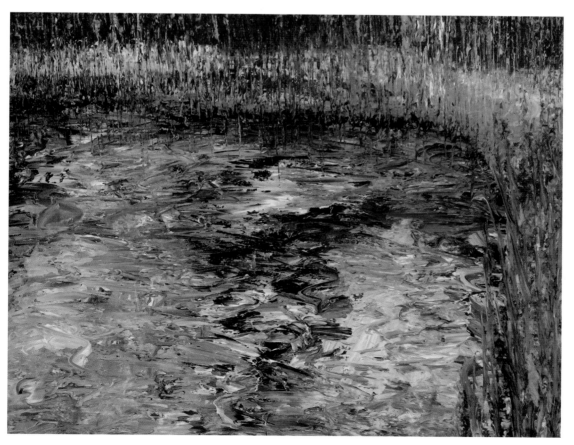

First Conversation with a Bog, Oil on Canvas, 20 x 24

Published by:

Pink Tomatoes
Amherst, New Hampshire

© 2004 by Randy Loubier

ISBN 0-9760757-4-1

Printed in Hong Kong by Egg Production International Ltd.

First Printing, January 2005

For bulk purchases and special sales, please contact:
Diane Bell
Expressions Gallery
172 South Street
Milford, NH 03055
603-673-2136
603-672-7212 fax
expressionsgallery@yahoo.com

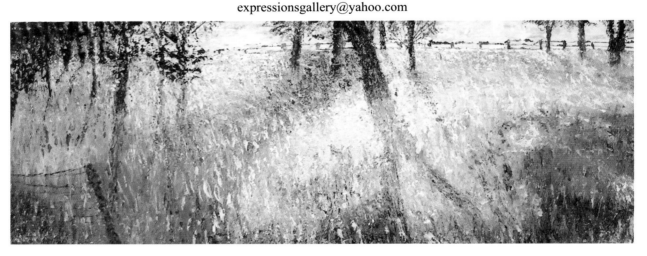

Sonoma Oaks II, Oil on Canvas, 18x48, 2003

www.pinktomatoes.com

A portion of the proceeds from this book will be donated to Angel Flight.
Keep flying, please.

Cover Photos: Front-The Iris Shed, 16x20, 2004. Back-Long Pond Pine, 11x14, 2003

To my wife, Judy—from whom I receive boundless love, light and passion—I could not have taken this journey without you.

A simple brush of hands,
The current of first touch.
A rush of lives past.
Oneness, commitment and loss.

Fall in love with a spirit?
All that and more.
God's sweetness surrounds you,
And opened my heart's door.

The other side must be dancing,
As we reunite this time.
I am deeply in love with you,
Our spirits intertwined.

Randy Loubier 2/14/2000

Acknowledgements

This book took far more time and effort than I anticipated. My family, therefore, deserves tons of credit for putting up with me hunched over my laptop for countless weekends and evenings. Of course, Judy was the most abandoned during this process; and I thank her immensely for supporting this book, my art, and me in general. Judy read numerous drafts and gave me many ideas that proved critical to its flow. I want to thank my daughter Tori, a terrific writer herself, for reading the manuscript and giving me some valuable thoughts. My parents gave me a sorely needed, honest critique on the first draft, and then scoured another draft for grammar and typos.

My friends, despite their own busy lives, rallied around this book. Marlis Moldenhaur reviewed one of the first drafts of the manuscript and gave me advice. Author Susan O'Neill ("Don't Mean Nothing: Short Stories of Viet Nam," Ballantine 2001/Black Swan [UK] 2002/UMass Press 2004,) not only reviewed two drafts of the manuscript but coached me extensively on the tone and voice of the book. Steve Lambert, a PhD in communications, gave me substantive advice on literary structure and rhythmic sentence flow. His comments on my book and the several long conversations we had were not only brilliant, but forced me through the equivalent of a graduate course in English. "Are you using language or is language using you?" "Verbs are powerful, can you say it another way?" "Can you find a way to communicate 'stunning day' by showing rather than telling—create it for the reader rather than label it?" "Say the sentence out loud—then remove a simple coordinating conjunction and an article—read aloud again, and hear the difference in rhythm" "Consider removing the commas to speed the sentence faster to its end, just like the moment." Frank Bajak, a senior editor with the Associated Press, took over where Steve left off and sanded the final rough spots.

Friend and fellow seeker Ed Marshall combed one of the draft manuscripts, but more importantly, contributed to the book with some 15 poems scattered amongst the photographs of my art. His poetry speaks to the concept of balance—at once simple and profound. Ed Marshall grew up in New England. He is a product of its forests and factories, its mills and mountains. Much of what he writes about can be seen from the window behind his typewriter. More of Ed's work is found in "A Nickel's Worth of Dreams" published by Palmetto Press, 2004. Ed plans to publish a more lengthy collection of his poetry early in 2005. He can be contacted at nhmass@aol.com.

THE VISION THING

It was a clear, crisp October 2000 night as I pulled into the Boston Copley parking garage. I touched my bow tie to make sure it was still centered, as I walked around the car to open the door for the love of my life. She looked ravishing that night as she stepped out of the car, kissed me, and held my hand on the walk into the hotel.

I was delighted to be out with Judy and looking forward to seeing my parents and friends. Several years earlier, my newly retired father had helped a colleague found a charity called Angel Flight NE. Angel Flight flies patients all over the United States to receive medical treatments. Hundreds of private pilots volunteer their time, planes, and fuel to make this happen. An extraordinary organization led by an equally extraordinary individual, Larry Camerlin. An ex-monk, he had evangelically lifted Angel Flight NE from concept to success virtually overnight. Tonight was the black tie autumn fundraiser event titled "Evening of Angels."

The rooms were filled with music, food, wine, and good cheer. My parents found us quickly and we talked for a while with Larry and his wife Ruth. We wandered off to view the many silent auction items, placed some bids, and eventually settled into the dining room for the main event—dinner and Larry's speech. It was to be a night that changed my life forever.

The cliché holds that "God works in mysterious ways." I am not so sure. I really don't know how God works. I am not sure he "works" at all. For 42 years, I had lived my life with a duality that I never understood. I had made a living with my left brain. In fact, as a child, I was the quintessential nerd. I wore thick glasses, loved to read and spent hours doing math and logic puzzles. I was reasonably active in sports, but I was only a fair athlete. I was better with my brain than my body. In my first three years of high school, my favorite course had been bookkeeping. I loved it. Bookkeeping fit my personality—it had a beginning and an end, there were rules to follow. There was a right and a wrong answer. It was, in my opinion, a perfect science.

But in my senior year of high school, the beginning of a life-long nagging duality stood up and whacked me across the head. Philosophy. I took a course in philosophy. And it was interesting. Imagine—the person who was sure that Nirvana was found in a journal entry, liked philosophy. What happened to the perfect, nay, *only* yin/yang of debit and credit? I don't know. I really don't know. But I found myself firmly engrossed in the writings of such philosophical greats as Socrates, Bacon, Nietzsche, and Emerson.

This seemed like a wonderful diversion, but when it came to finding a college, my recent sacrilegious foray into the non-concrete caused me to lose my focus from my previous first choice of Bentley. I ended up at a liberal arts school—Hobart College in Geneva, N.Y.—instead. In my first year, I continued my exploration of the fluid world of philosophy by studying different religions. Raised Roman Catholic, I quietly rebelled by enjoying a practice of meditation and studying the teachings of Buddha, Mohammed, Jesus and Moses.

But by the end of my first year in college, I had had enough. The soft pillow of the ether didn't push back enough. I needed the fences, I needed the spiked bedding and the whips and chains of the logical; I needed my debits and credits to add to zero—perfectly, to the penny.

So I joined the Air Force. What? What happened to accounting school? I don't know. God works in mysterious ways … perhaps? The logical part of this was that money was tight and I frankly needed the financial help that the military would provide to finish college. The emotional part was that I was enamored with serving my country and traveling the world.

After dinner, Larry stood up and spoke of the Angel Flight mission. At over six feet and 200 pounds, Larry is a handsome and youthful man in his mid 50s. His voice is entrancing. His demeanor is sincere. And his enthusiasm for his mission is more than infectious—it is heart-rending. Within five minutes, Larry had most of the audience fighting back saline. He talked about a little girl who was in an accident and burned over 90% of her body. Severely scarred and disfigured, she had taken nearly one hundred flights from Maine to Boston to get the world's best doctors to not only keep her alive but to give her more freedom of movement from the scars that enchain her body. Behind him on a screen, a picture flashed of Larry getting a big hug from the little girl.

I squeezed Judy's hand, thinking how lucky we are to have each other and our wonderful children—we are a blended family with three of her children and three of mine. I looked over at my mom and dad and felt the blessing of familial love—two parents who have unconditionally supported me all my life. I looked back to Larry on the stage, and perceived beside him a painting—a beautiful painting of an airplane with a halo. It was done in an impressionist style, with rich reds and golds. The airplane was flying out of the darker clouds and into the light. Wonderfully symbolic of the Angel Flight mission. Wow, a gorgeous painting. Blink, blink. Clear some tears. Blink. No, there was no painting. It was just a vision, my imagination—but what a stunning piece of art, I thought.

Larry went on to talk about other patients and the big-hearted pilots. By the time he wrapped up his talk, there wasn't a dry eye in the place. We stayed for the live auction, gave everyone big hugs and headed home.

It was midnight when we got to the car, and an hour's drive home to Amherst, New Hampshire. After we left the city and settled into the drive, I shared my vision with Judy. She loved the description of the painting. We talked about how fascinating it is that ideas just pop into one's head occasionally. And wouldn't it be great if we knew someone who could paint it.

A moment went by and she said, "Why don't you paint it?"

I laughed out loud. "I am an accountant, sweetheart. I am not an artist. In fact, I couldn't be any more opposite than an artist."

"Well maybe," Judy replied, "but you should consider it anyway. You are a great photographer, you love to see art at museums, and besides, didn't your grandmother paint?"

"Yes, love, but first, I really am just a fair photographer; and second, just because my grandmother painted doesn't mean I can rewind my functional, everything-in-its-place personality and play somebody else's artistic, free-spirited, slap-paint-on-a-canvas personality.

Besides," I continued my line of reasoning, "artists grow up being artists—they grow up drawing, coloring, and doodling. I did not. I disliked drawing. Worse yet, I didn't even like coloring. It always seemed like a pointless waste of time. Beyond that, you have seen me around crafts, another thing I do not like to waste time on. I once had to make an ash tray at summer camp. I was eight and nobody I knew smoked, but there I was, making a silly ashtray out of little miniature tiles. That sealed it for me—that was the start of my lifelong loathing of producing arts and crafts."

Judy understood how I felt, but still suggested I should think about it.

Maybe that was a hex. Think about it. Possessed is the right word. That night, the painting haunted me. It was past 1 a.m. when we got home and I was tired, but I did not fall asleep for a very long time—and later when I did, I was awakened by the image.

Over the next several nights, I got a little more sleep, but it was restless sleep at best; and I woke up in the morning with the airplane painting screaming at me. I buried myself in work each day—and at night dreamed of creating.

The next weekend, I discussed the situation again with Judy. I told her what was going on for me. She suggested I do something about it—just go get some paints and try it. This set me off on another long monologue of who I am and who I am not. I gave her every excuse I could think of including my final one—which seemed like a perfect closer: "Besides, painting is expensive; we can't afford it (true to my tightwad, accountant, Yankee heritage)."

Ever the sweetheart, Judy just listened and when I was finished, she said innocently, "What makes you think it is expensive?"

"My grandmother always told me not to play with the paints—they are very expensive."

Judy smiled and said, "Why not go to the store and see how much they are?"

It was Saturday morning. I went. I remember thinking there was no downside to this idea of going to the store because if they were expensive, I wasn't wasting money on them; and, if they were inexpensive, and I bought them and failed at painting, Judy would not laugh at me. Judy would let me fail with dignity, I was certain of that.

THE AIRPLANE THING

I came home with a big smile on my face. For $25, I had a starter set of acrylic paints, a starter set of plastic brushes and palette knifes, a plastic palette, and several pre-stretched canvases. I was ready to do it. Why not? I was pumped, I was primed; I was ready to be the next Monet. Somehow, in the 45 minutes of going to the store, I suddenly forgot who I was. Why can't I paint? Of course I can paint. I can do anything. Let's go. Let's do it. Let's paint a masterpiece. Larry is going to love this. Imagine my parents' pride. Imagine the look on Larry's face when I present him with this amazing painting.

And so I began. I spent hours translating the image to canvas. I kept my enthusiasm high, despite some setbacks, and pushed through. I started the basic layout on the canvas with a pencil. Then I squeezed the paints onto the plastic palette and carefully laid in the paint on the canvas. I started with a background in the colors I imagined— beautiful rich reds and sparkling golds.

This is where I ran into my first problem—the red and yellow I had in the starter kit looked wrong against each other. I couldn't explain it at the time but the colors just were not as happy as envisioned. Somehow, they seemed sad. And bloody. Yeah, bloody. When I finished the background it looked like Discovery Channel's close up of an appendectomy—hardly the warm, comforting feeling I wanted to transmit about the life-giving Angel Flight organization. By the time I was done with the background I knew there was something wrong with the painting.

But I was determined to keep going.

I got a drink of water, and pushed through. No matter that the background is a little off, I thought; I will save it with the incredible airplane I am going to paint.

I worked on the airplane for the next hour or so. Nobody had ever taught me to draw. I had never wanted to learn. The airplane I started with enthusiasm turned into a pathetic, disfigured blob of white/blue/red/pink/orange gook.

But, I thought, I am teaching my kids to persevere. I am not going to be a quitter, not yet anyway. I can still save this painting. I'll save it with the halo.

Ten minutes later, I had the halo on the airplane. And that did it. It was the finishing touch I needed. I stepped back. Voilá.

The halo had transformed the painting, all right. The blob with the halo now looked like an alien. The painting, in its entirety, looked like a bloody intergalactic battle scene. My 3-year-old stepson had painted better than this.

I sank into misery. I wasn't all that surprised, but I was really disappointed. Really discouraged. I wanted this to work. I wanted to believe I could be an artist. How many museums had I been to, appreciating the great masters? I had even toured Giverny, France, enchanted by the home and gardens of one of my all time favorite painters, Claude Monet. My front hall was adorned with photos from that trip. Wasn't that good for something?

I am not an artist, I said to myself. I am an accountant. And I proved it. Experiment over. I am done with the humiliating feeling of underachievement. I am a damned fine executive, though. I am. I can hang my hat on that—and I don't have to wonder any more who I am not. Better yet, I will sleep tonight having that stupid image out of my mind.

I walked out and closed the door. In a few minutes, Judy asked me how it was going.

"Not so great."

Judy went in to view the crime scene—the murder of my momentary alter ego. She was sweet, "Okay, it isn't what you wanted. Put it aside and try it again—you have some more canvases, right?"

I laughed, one of those tired, frustrated laughs. I felt so many feelings all at once. I was all twisted tight like a gigantic rubber band ball. I wanted to believe I could get inside the ball and find that other guy—the artist. I wanted it badly. I had had a taste of it now—the sweet smell of the paints, the feel of them against the canvas, the sensation of squeezing them from the tube and anticipating the color before it oozes out. I had seen the glorious image of the paints mixing on the palette, the swirls of color dancing with each other like nymphs.

I had experienced moments of getting inside the rubber band ball before. I had written some poetry and felt the holy moment of having the poem come together in the end. When it fit, when it felt just right, I knew it. I liked that feeling. I had also gotten inside the ball when I had written speeches and delivered them well.

And there was that philosophical side of me—the side of me that was okay with not knowing the answers—the side of me that enjoyed meditation, that was okay not knowing what, who, where, when or even if God existed in any of the ways others thought he did. How did that guy fit in here? Was the guy that was okay with the ethereal the same guy inside the rubber band ball?

There was a lot to think about. Moreover, aside from thought, I was bursting with emotion. I was angry that the airplane painting didn't come out right. I wanted to give the painting to Larry and I was angry and sad that he would not have it. Beyond anger was fear … fear of failure. The jaws of failure leave teeth marks in the skin of self-esteem. I knew rationally that I was not a failure if I couldn't be an artist. Nevertheless, feelings are feelings, logical or not. In the short week that the vision had been haunting me I had had frequent fantasies of finding that artist inside.

If I couldn't get the airplane to work did this mean that I was finished with ever being anything but an accountant? In addition, if I felt *that* way, did this mean that I had always harbored secret thoughts of wanting to be something more? No, I don't think so. I was proud of my career. Furthermore, what's wrong with being an accountant? I could fit into a mold, couldn't I? Molds are predictable—I had sought the safety of the mold many, many times in my life. It was like home—warm and cozy—like a fleece blanket at the meditative end to a Yoga session. But, damn, there's that duality again. Yoga. With it's proper forms and breathing, giving way to a more free flow of

life spirit. What is it with this continual struggle to find balance? Why can't I just be an accountant and be happy with it. But, I am happy. Very happy. And on and on and on…

I kissed Judy and said, "Okay, I'll sleep on it and see what the morning brings."

I really didn't know what more to say right then. I was really frustrated, but how do you put into words every rubber band in the ball? Besides, I am an accountant—we are all lousy communicators—check the Microsoft Word thesaurus for "accountant" and they confirm that you can use "lousy communicator" synonymously.

Later that night, however, Judy was able to get me to peek under some of the rubber bands. She asked me some perfectly phrased questions that led me to communicate a little more about my feelings over the day's tragic experiment. Venus is a good place, guys, really. I know I am from Mars. I fully admit it. But, sometimes just talking about it does help. No fixes. No answers. Just blah, blah, blah, blah, blah. And you come out on the other end with a better night's sleep. And after all, coming from a sleep-deprived week, perhaps the real objective for the day was to just get a good night's sleep.

THE BOAT THING

And sleep I did—like a baby with a pacifier.

Only to wake up with another image burning a hole in my third eye. No, not again!!!!! What is this? A sunset over a pond—with a boat? What happened to the airplane? No answer. Gone. Done with the airplane. Try this sunset and boat.

Oh no. I failed yesterday and I am tired of this—just leave me alone. Please. I closed my eyes.

No luck. What's that cliché—"No rest for the wicked?" I was wicked, all right. Wicked frustrated.

I got up, got a drink of water, and went to look at the mess I had made the day before. The painting was laughable. It was downright gory. The Alien Bloodbath—a catchy title at least.

The palette was a mess, too. The acrylic paints had stuck to it and would not come off. Oh well—it was 59 cents, I thought (Yes, I remembered how much it was—are you getting a picture of who I am?). Well, this next painting—it'll be the last—I can just squeeze the new paint right on over the old paint on the palette.

I sat down for a few minutes and stared at everything. My mood improved slightly after a while. And I started to get the idea that I should just loosen up and have a bit of fun. Okay, I said to myself, let's do the sunset with the boat. Oh, but wait, the image I had was tall and narrow. I have two 8x10 canvases left so let's just screw the canvases together. It will be tall and narrow. But won't it look ugly with them

screwed together? Yeah, but I am going to throw it in the garbage anyway; and, on the off chance that I like it, I'll just unscrew them and hang them one over the other— I've seen it done before. Let's do the sunset/boat thing, use up the last two canvases and be finished—for good.

In addition to the starter set of brushes, I had also found one big brush at the art supply store. It was only a quarter. And since it was only a quarter, I had purchased it. It had a brush head that bled hair like our cat, mounted on a cheap piece of tin formed into a tube. By anybody's standards, it was a bad brush. But I liked it. I had some sort of utilitarian connection to this brush that made me feel alive, frugal and wise. A twisted logic that said that if I failed as an artist, and I already had, I was going down swinging a really cheap brush. I picked up my proletarian probe and gobbed a bunch of paint on it.

I was determined to go after the sunset like it didn't matter if I failed. The whole painting thing was over anyway, so now it was just time for a little fun. I pushed the paint around on the mated canvases, picked up more paint and pushed that around. I mixed the paints together as I swooped them up with the big brush, laying them on without thinking. I worked from the top to the bottom. The golds and oranges of the sky came first. The sun came next like a giant ball of flaming gasses (weird, huh) loosely formed, like a hazy day. Then below the sun, I mixed in some greens to keep the painting from burning to a crisp before it sizzled into the deep blue pond.

The background was finished. I stepped back. Hmmm… Hmmm, some more.

I think I like this. In fact, I think I really like this.

I went to fill my water glass and came back in the room. I still liked it.

But then my brain kicked in. Wait, I *can't* like this. I am an accountant. I am not an artist. I'll bet this is one of those occasions when I am caught up in the moment—like when I thought it was a good idea to use my little sister's bike to do wheelies and I ripped the handlebars off the frame. I knew I was too big for the bike, but it seemed like such a good idea at the time. I might like this painting now, but when I get a grip on reality, I will see it for the crap that it is.

Then, it got worse—I remembered the boat. My arm got stiff just thinking about it. The thought of the boat was making my left brain jump back in so it could control the action. The background had been fun—it was free and easy. I liked the colors and the texture so far. There had been no thinking—just doing. But the boat, on the other hand, that would require a lot of detail, a lot of precise movement that had to be controlled. My left brain twitched into action while my right brain took its familiar back seat.

I had to paint the boat. I was supposed to paint the boat. I picked up a small brush, sized up the canvases and got some paint on the brush to begin the boat.

Wait… Let's wait. I am not ready for the boat yet. Give me a second to think.

I sat down and stared at this fire and water creation. What do I need the boat for anyway? I don't even like boats. I usually know what I like, and I like it just the way it is.

On the other hand … the image I woke up with had a boat in it. I think I am supposed to put a boat in here.

I was frozen with indecision. So, I did what any self-reliant man would do; I brought my wife in to tell me what she thought.

"Wow, Rand, I really like this. Wow, wow, wow, I *really* like this. You know where this would look great—in the new bathroom. Let's see what this looks like in there."

In the bathroom we went, before I could even tell her that it might not be finished— What about the boat thing?—I was thinking. She had me hold the painting up on the wall. She liked it there. We swapped places—she held while I looked. Yeah, I thought, it did look good there.

I said, rather sheepishly, "I am not sure it's finished. I had wanted to put a boat in it. But I kind of like it just the way it is. What do you think?"

"I think you should do whatever you want, Hon, but I can tell you I really like it just the way it is."

She hesitated to get my reaction. I just stood there silent. I didn't know what to say—I was out of my element.

Judy added, "I don't care for boats much, do you?"

"No."

"What made you think you wanted a boat in it?"

"I don't really know."

I am *such* a good communicator, aren't I? But, it all seemed stupid right then. The whole airplane thing was bad enough, but now the boat thing was like a bad dream— literally. I didn't want her to think I was losing it. How much of this could anyone witness before they called for a straight jacket? I am an accountant. I am predictable. I get to my appointments on time. The world is concrete. If it's broken, fix it. If it isn't, leave it alone. I felt lost—disoriented. So, forget the stupid boat and let it be done. This seemed like a very good place to end all this madness. Forget the boat; let's be done with this crazy experiment.

But just when I thought the coast was clear, because the "I don't know" answer had worked, and I was certain I didn't have to think about this painting thing any more, she said, "Great, then it's settled, let's go get it framed."

This was *not* what I expected. *Framed!?!?!?!?!* Crisis number 127 was in front of

me. Do you have any idea how much frames cost? I knew. My first wife had some things framed and I nearly had to take out a home-equity loan for them.

Worst yet, there were two canvases. I was the moron who screwed the canvases together. You could see the seam, so they had to be separated. The fiscal SOS flags were waving frantically. Dumb. Dumb. Dumb.

Then it occurred to me that another crisis was at hand, one without a number because I had never faced it before. *I can't have anything framed. I am not an artist. Having something framed would mean I am an artist. I am an accountant.*

I imagined myself walking into the frame shop, asking to have this "art" framed. What do I say if they ask who the artist is? I have no answer for that. What if they like the art? What if they *don't* like the art? What if they *pretend* to like the art but come to the conclusion that there is no frame for this art? Translated as "no frame for this crap."

What if we run into somebody we know at the frame shop? "Oh I didn't know you were an artist?" "No, I am not an artist—I am just goofing around." "And you are spending good money getting this 'goofing around thing' framed?!?! What has happened to your sense of monetary prudence, Randy? Aren't you an accountant? Are you okay? Get a grip on yourself, boy."

No, I am not okay! This whole thing hurts—it *hurts*.

I was so exhausted from all of it. I hadn't slept well for a week, I had no idea who I was anymore, and my head was exploding from all the pain of trying to figure out something my left brain just couldn't figure out. I had no idea what to think.

I eked out, "Okay, uh, you really like it that much?"

"Yes I really do. I knew you had it in you. I love it. I love you. Let's go get it framed."

THE BRAIN THING

Diane Bell is a small, attractive woman, quiet spoken and with a great reputation for having a special eye for art and framing. She has a gallery in the small town of Milford, N.H. Not a lot of original art is sold in Milford, so most of her business is done in framing and gifts. Everyone brings their art, posters, plaques, certificates, degrees, etc., to Diane. She is *the* framer in the area.

She very calmly took the two canvases from me and remarked how beautiful they were. She is good, I thought. Good at something. Either art, or making us feel good about spending our 401K on getting these framed.

"Did you paint these?"

The question was asked. Oh, boy. I floundered. Shuffled my feet. Gulped. I tried to clear my throat—there was a 67 Volkswagen in the way.

"Yes, he did, aren't they gorgeous." My wife to the rescue.

We picked out some beautiful frames that would work with the paintings and the bathroom.

That chance meeting of Diane turned out to be God's work (or something at work, since we aren't sure if God goes to work or not). She became extremely important in helping me step out into the world with my art. But that would be getting ahead of the story.

Getting that second painting framed—which by the way has a name, "Sunset Over Autumn Pond"—was also important because it gave me the confidence to keep going.

Those first two paintings had taken so much out of me; but when I got home from the frame shop, I was healed. I suddenly forgot all the pain I had been through. My head didn't hurt any more. Judy asked me when I was going to get more canvases and I said, "I can't get there soon enough."

Over the next six months, I painted every minute I could. I bought nearly every color of acrylic paint I could find. Images continued to come to me—almost every morning I had a fresh image waiting for me when I awoke. And I was fully engaged in the opportunity to create anew each and every time.

I learned a lot over those months. It was all on-the-job-training, though. Yes, I bought a couple books and skimmed through them. But the more I painted, the more rubber bands spun off the ball. And the more bands that twanged away, the less interest I had in learning anything from anyone. I didn't take a lesson; I didn't talk to anyone about it. I just painted. Canvas after canvas. I didn't want any rules. I didn't want any molds. I didn't want any advice. I just wanted to paint.

I stuck with the big, ugly, cheap brush, too. My twenty-five cent investment had yielded the tool of choice. It was a monster when it came to laying on paint. Scoop it up and slather it on.

The most important thing I learned, though, in that first six months was the brain thing. I got the right brain connection. I got it. I figured out how to get my right-brain to isolate itself enough to fight off the left brain's overpowering personality.

Growing up the way I did, choosing the profession I did, my left brain had become accustomed to being the bully on the block. The left brain knew it was in charge and rarely even acknowledged the right brain, much less let it do something useful.

The experience of pushing out those first two paintings was painful. I wanted so much to let my right brain go and create the images freely. But the battle that was going in my head was not only disconcerting; it made me shake from exhaustion.

In the ensuing months, I found that the best way for me to lose the left brain, and

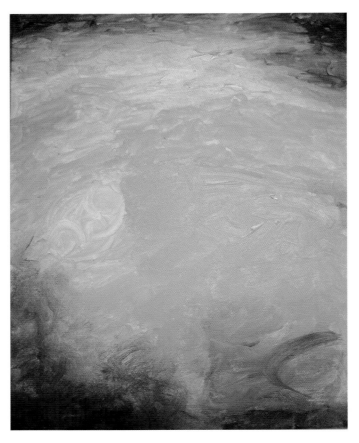

Sunset Over Autumn Pond, Oil on Canvas, 2000

14

thereby diminish the battle, was to avoid detail in the paintings. The fact is that I always liked paintings with simple compositions (and would later realize these simple compositions were an integral part of my art form), but in the beginning I *had* to create paintings with simple compositions and little detail. It was the only way I could create a painting I liked. Every time I allowed more detail to come into the painting, my left brain muscled out the right and the painting was a failure. In fact, it was nearly three years of painting, well over 150 canvases, before I created a successful painting with moderate detail—"Mother's Day" was a true breakthrough painting for me in September 2003. I created "Mother's Day" on a marathon three-day weekend (Judy and I don't have our children every other weekend, so I often fill this void with painting). I was able to manage a fair amount of detail in the painting, and used many measurements to get the perspective of the painting correct, but still was able to switch very rapidly back and forth between exacting left and free-spirited right. I am not suggesting I liked the process—I didn't—but I was able to create a painting that I liked, despite all the detail.

What's strange—and I know this will sound bizarre to some—I started to *feel* the shift from left to right. Weird, I know. But I have already humiliated myself with my other inner secrets. Seriously, I could feel my brain switching from left to right. I would come home from a hard day at work; and as soon as I entered the studio (it didn't take me long to commandeer a room in the house for my art), I could feel the shift start to take place.

The shift is subtle—no giant bells gonging. But here is how it goes: The first phase is the melting/shrinking phase. My left brain will start to soften and melt, and then to shrink a little. Underneath and right of center, my right brain is slowly exposed by the melting/shrinking left brain. This gives the right brain an opportunity to breathe. After the first transition, when the right brain gets to peek out from underneath the bully, I can start painting. Then within minutes, the second phase starts. This is where the right brain looks out to see that the coast is clear, and sheepishly, cautiously starts to absorb energy to grow. Sometimes the right brain will grow to be larger than the left and really dominate a session. Those sessions are the most fun. Other sessions, particularly prevalent in my first months and then even later, when I intentionally tried to go after detail, the left brain wouldn't soften up enough to allow the right brain to get out from underneath it.

I was lucky to discover an important lesson in that first successful painting, "Sunset Over Autumn Pond." I knew the first part of the painting, the background, *felt* good. And when I considered painting the boat, it didn't feel good.

I didn't put all of this together that day or for some time to come; but over the next several months I was sensitive enough to recognize that there was a pattern to when I liked a painting and when I didn't. I liked the paintings that were created when I didn't have much detail in them. Then I connected the dots between too much detail and the twitching, fumbling left brain. What naturally followed was a tendency to want to do paintings with little detail in them because I had a better chance of liking them. What I didn't realize until much later was that I was giving my right brain an opportunity to grow in strength with each successful painting. The more I practiced giving my right brain a chance to dominate a session, the more effective it was, and

the greater the chance it could survive when the left brain was having a particularly strong day. That is how, nearly three years later, I was able to create "Mother's Day."

THE EARLY WORK

During this first six months while I figured out the brain thing, I painted some paintings I liked but I also created some awful paintings. One of the ugly paintings that our kids still love to tease me about was something they dubbed "The Hambone." I wish now that I had kept it so you could have a good laugh too. I ended up painting over it—so it exists somewhere underneath one of my good paintings.

"The Hambone" was the second abstract that I had attempted. The first abstract I did, "The Creative," was a success. I really loved it. It still hangs in our home. "The Creative" was a breakthrough painting for me because it was the first painting I completed that was intended to be simply color. No intentionally recognizable forms. It was also a breakthrough because you can see the roots of my later work—the movement in the paint. The intense passion expressed through this movement, and the interplay of the colors against each other, create a connection that you can feel as you stand in front of this painting.

So, fresh from this fantastic success, I was determined to pursue more abstracts. But, I went off in some direction that I still don't understand. I did not intend to create a painting of a bone, but it ended up looking like a bisected femur—complete with bone marrow channels and dripping blood. It was really terrible. The kids all remember it for the failure that it was—which is exactly what fathers should teach their kids. It is okay to fail—don't let it hold you back—laugh along with everyone else—and *keep going*.

There are a number of others from the first six months that, in my opinion, fit in between "The Hambone" and "The Creative." I like them enough to have not destroyed them and I think they are representative of my early art. "Copper Roses," "Café Secrets," "Terra Cotta Path," and "Twilight Café."

I painted the first three with my big, ugly, cheap brush. You can see how I blended color on the brush and swirled it onto the canvas. I was well aware that most people don't paint like this, but I was much more intent on pleasing me. I had a phrase that I repeated constantly to myself. Like a rallying cry, I would shout in my head, "I am painting for ME." I didn't want to be confused by whoever might not like it, whoever might think it was bad art, whoever might think I was a deluded accountant trying to be someone else. I wanted to paint for an audience of one—ME. That's it. If I liked it, then it stayed. If I thought it was garbage, then it was either set aside, painted over or heaved.

It is hard to convey the plethora of feelings I went through in the first six months of painting. The pendulum swung from frustration to thrill and back again, frequently.

While I had discovered my right brain and was able to access it, my left brain was not happy with the intrusion. My left brain felt like the established house cat when a new

Café Secrets, Acrylic on
Canvas, 8x10, 2001

Twilight Café, Acrylic on
Canvas, 18x24, 2001

Copper Roses, Acrylic on Canvas, 24x30, 2001

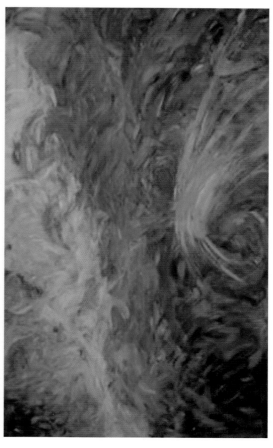

The Creative, Acrylic on
Canvas, 24x36, 2001

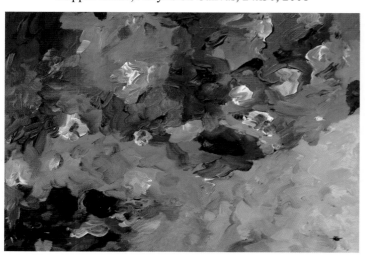

Terra Cotta Path, Acrylic on Canvas, 18x24, 2001

puppy is brought home—truly insulted. This was new tension for me and was the source of a lot of frustration. The puppy wanted to play, and this annoyed the house cat. Neither one understood the other, and like a bickering couple, the noise was overwhelming at times. My left brain tried to think through what was going on—how could this be happening, what is happening, what is the source of these images, why is this enjoyable, how could we do anything worthy without thinking it through first? Those were the worst moments—my left brain ached and missed the old days when that stupid puppy wasn't around.

At the base of the pendulum swing I sometimes experienced moments of peace when, somehow, my left brain would relinquish the thinking, and relax.

And of course the pendulum would also swing to the peak on the other side and I would experience the absolute thrill of *loving* a painting when it was complete.

We use that word "Love" a lot in our house. We are a family that expresses our love freely and I found myself falling in love with many of my creations. It is not the same love you feel for your partner. It is akin to falling in love with your baby when he or she is born. You must remember the feeling of falling head over heels in love with your baby? That first moment of seeing the little creation that came from your life. You know what it is like—that moment when you see your baby as a helpless little blessing from God. And you swear right then that you will be the best, most vigilant, most loving parent on the planet. That moment is creation. You have fallen in love.

I am not suggesting that my paintings were anywhere near important to me as my children, but this example of parental love *is* falling in love. I felt a similar falling in love with many of my paintings.

"Café Secrets" is that way for me. It was created with the swirls of the big, ugly, cheap brush. It was created with a fluid, rapid movement that made me happy. It was intended to be just a loose "whatever"—a good time. Just a fun movement of the brush. Pure passion, no intention. And when "Café Secrets" came out, it was love at first sight.

Another important development in the first six months, sometime between "Café Secrets" and "Twilight Café," was switching over to the palette knife. I still have the big, ugly, cheap brush; but by December of 2000—just a couple months after I started painting, I began to cheat on the big ugly. It started as just an innocent idea. I was mixing paints on the palette with the palette knife. The knife had a lot of extra paint on it. I am cheap. I thought, "No sense wasting the paint—put it on the canvas." I did. It felt good.

And I wanted more. I continued to use the big ugly, but I had met my new lover. By March of 2001, I had dispensed with the big ugly altogether. It still stands in my studio, and I pick it up now and again, but… the sex appeal of the palette knife had hooked me, and reeled me in. With its curves in my hand, the spring of life in its blade and the practical clean up (just a swipe with the paper towel) it is an accountant's Helen of Troy—a goddess of strength worth fighting for.

UNCLE DICK

I met Richard Hill Chase for the first time in April of 2001. Since Judy and I had not been together all that long, I had not had the pleasure of meeting Judy's favorite relative.

Uncle Dick had invited Judy and me down for a couple days, "But don't bring the kids!" he had said. So, on a week when our children were all on vacation with our respective ex-spouses, we drove down to see Uncle Dick. On the ride from New Hampshire to Pennsylvania, I had no idea what a treat I was in for, or how much influence this retired art teacher would have on my art.

Born in 1930, flamboyantly gay, strikingly handsome, loud and gregarious, Uncle Dick had grown up in an era when it took courage to express who he was. His family was never quite certain what to think of him. They loved him, but he was not like the rest of them. Uncle Dick did not hide who he was—he loved theatre, art, music, handsome men, friendship, fine clothes, intelligent conversation and Democratic politicians. He was an extraordinary man with an extraordinary wit and a never-ending zest for life. So, while some of the world just tolerated Uncle Dick, the rest of the world enjoyed him.

And Judy was a part of the rest of the world. She loved Uncle Dick. When Judy was in her 20's and had to do some graduate coursework in New Jersey, she lived with him for eight weeks—this extended time together cemented a bond that most of us will never have with an uncle.

Uncle Dick knew that I had started painting six months earlier and had suggested I bring some paintings down for him to see. After introductions, hugs and our first glass of wine, I brought out the paintings.

"Hmmm."

Pause.

"Hmmm."

You can imagine what was going on in my mind. I was in front of a man who I knew was important to Judy—and Judy was extremely important to me. Furthermore, I knew he had an eye for art; his place was filled with terrific art—not only his own but a great collection of other artists. And, he had taught art for 30 years. My self-doubt was spiking off the chart. Damn, this was not a good idea. Why did I do this? I knew this stuff was crap. I knew it. I wanted to crawl under the coffee table.

I thought about salvaging the situation with, "Look, I know this stuff is crap, but don't worry, I have a day job as an accountant so I will take great care of your niece, I promise." However, this might backfire because I would then reveal to him that I was a Republican (all accountants are Republicans, aren't they?).

"Hmmm…I like this one…" He was pointing to "Twilight Café." "But…Hmmm."

I shuffled my feet in the silence.

"But...Hmmm."

This was clearly a big "But." What, already? I am dying. Just shoot me.

"I know what I am going to teach you this week—how to mix your colors, Randy. Your colors aren't right. You are either mixing them too much to get mud (pointing to "Café Secrets"), or you are letting the colors fight on the canvas (pointing to "Twilight Café"). You have to learn the rules of color mixing. You need to make your colors sing, Randy. They need to sing. Now let's go to dinner. We can talk about this more tomorrow."

That was it? That was 30 years of teaching wrapped up in a few sentences?

I would come to realize that this was Uncle Dick's method. He wouldn't say he didn't like my work, even if he did. Nor would he dislike my work just because it was different from his—he was a landscape and still-life artist with a penchant for very fine detail. Better yet, he wouldn't disrupt my self-exploration by making me fit somebody else's idea of art. His method was to add concepts, ideas and techniques to my quiver. He put me through exercises to learn skills that would complement my art's direction. Several times, he sent me brochures from art shows that were annotated with arrows and notes. "Randy, look at how close these strokes are together." "See the color contrast here—that is done intentionally to create tension—it will draw the eye to that spot." "Now look at this color contrast—this green doesn't come from the prime—it was a bad choice—it created tension in a spot that needed harmony."

Occasionally he would push me—he would ask me a question or make a comment that forced me to evaluate my work. When I first met him, he knew that I was struggling with finding my voice. It was obvious from the work I brought that I had tried many different techniques. I was searching—in my own way—in my own time. He knew that.

One time during that first session with me he said, "You need to get control over that palette knife, Randy." He was pointing to the foreground of the road in "Twilight Café." You can see that I had gone a little crazy with the palette knife with some big strokes.

When he made that comment, I didn't reply at first. Maybe he was right. Maybe I really should get more control over the painting process. But of course, this was the struggle for me.

I replied a weak, "Okay." I didn't know what else to say—I had some thinking to do.

And think I did—for weeks after that. What is right? The truth is, I loved that part of "Twilight Café." In fact, it was one of my favorite parts of the painting. It was free from control. It was "painterly." It was my alter ego, the artist, saying, "Screw you—you stupid, boring accountant. I am going to make a road that doesn't look like a perfect road. It is going to be a messy road ... because I want it to be."

But on the other hand, the accountant in me was responding, "Huh! Told ya! You thought you were going to get away with a mess; but look, even the art teacher is telling you that the mess is not acceptable!!!! Listen, you. You know you aren't supposed to color outside of the lines. Stop breaking the rules. Just get back to the accounting personality and get this stuff *under control*."

Eventually, the accountant lost this argument—he had to, or you wouldn't be reading this book. In time, I came to value this statement about controlling the palette knife as one of the most profound statements Uncle Dick made to me. There were many other statements he made that pushed me to choose a path, to find my voice. But none were as powerful as this one. Once I took a stand on the topic—that I was not going to control the painting, I was going to let the artist in me paint it, just the way it felt—I found the octave of my voice. The rest of the notes would come—the harmonizing parts would form even later—but the base octave of my voice was discovered in that one lesson.

You can see that base octave in all my work. I am not at all interested in the detail. I like to put enough detail in the painting to ground the viewer in the scene—I want the viewer to recognize something in the scene so they know roughly what it is. But that is it.

So, four of us went to dinner that first night—Uncle Dick and his friend Jack, Judy, and I. Uncle Dick's custom was to sit at the bar first to have a drink. He always had a drink at the bar before dinner. And it didn't matter where he was, in his hometown or far away, Uncle Dick would make friends at the bar. He was larger than life and had apparently always been so. As a younger man he stood very tall, dressed exquisitely, held himself confidently, spoke loudly, laughed even louder and was a witty, sometimes sardonic conversationalist.

Now in his seventies and in a wheelchair, he no longer stood tall; but he still had all the other attributes of a well-traveled, well-read, confident man. Soon after we entered the bar, Uncle Dick had the attention of its entire clientele. "I need a drink," he announced loudly, "what can I get for a quarter?" Everyone smiled.

"This is my favorite niece, Judy, and her boyfriend. They came all the way from New Hampshire to see me. She is a tramp, but I still love her."

And with those lines, we were set for the evening to enjoy conversation with whomever was there. Judy had told me about Uncle Dick long before we arrived, so I wasn't surprised. I was intrigued. I am more of an introvert than an extrovert—and have always been interested in watching gregarious people in action. Uncle Dick was naturally extroverted. He had no motive in engaging strangers—he just did it.

And therein was another lesson for me. As I was discovering this other side of me— the artist—I was witnessing in my mentor someone completely unencumbered. It became another reason for me to believe that it was okay to allow my artistic self to be unencumbered. It was another reason why I was able to allow the accountant to lose the battle of control over my art. It was another reason why I was able to decide

eventually to let my art out into the world—unencumbered, uncensored and with little concern whether someone might not like it.

After dinner that first night, we returned to Uncle Dick's house. He got out some of his art books and looked up various artists that he thought might inspire me. I took notes. It is still astounding to me that, after just a brief viewing of my fledgling art, that he was able to pinpoint the artists in whom I would find inspiration. Nikolai Timkov, Nicholas de Stael, Joseph Mallard William Turner, Gustav Klimt, Claude Monet, Vincent Van Gogh, Pierre Auguste Renoir, Jackson Pollock. The artists from this list that I already knew, the last four, were already some of my favorites. The artists that I had never heard of, the first four, were soon to be new favorites.

How could this be? How could any teacher intuit style this well? These were not Uncle Dick's favorites. He had his own posse of masters he admired and drew strength from (which he later shared with me—Andrew Wyeth was one of the strongest). So, how did he know who was going to provide that long-distance, ethereal kind of support to my developing voice? I don't know. I really don't.

Uncle Dick's first lessons all revolved around color theory. My left brain had a field day. Theory? Oh yeah, I am all over that stuff. Compliments, split compliments, tones, etc. I ate it up. It was foreign language at first, but I quickly got the hang of it.

We mixed paints in his studio for many hours. He showed me how to mix a tonal chart. He then had me choose a prime color from the color wheel and showed me how to mix all the other colors from that prime. He showed me how to mix black. "Never use black from a tube—you have to make certain your black comes from the prime color you have chosen. All the colors you use must sing together, even the black.

"If your colors sing together, viewers know it; they will feel it. They may not know *why* they like your painting. And most will certainly not know that it has anything to do with your harmonizing colors; but they will react. You wait and see. They will react."

SPREADING BUTTER WITH LOVE

I went home from that first visit to Uncle Dick with a charged spirit. I was even more convinced that I was pursuing a natural love. I immediately went to the store and bought my first oil paints. Clearly, if I was going to follow Uncle Dick's methods of color mixing, I had to use oil paints—the acrylics dried too quickly.

Furthermore, the experience in Uncle Dick's studio of mixing oils had introduced an addiction. The consistency of oil paint is soft and luxurious. Like when you put peanut butter on hot toast—a minute later it is soft, almost runny—and you take that first great bite. Or salt-water taffy being made as you watch from the window of the Cape Cod storefront—it is soft and gooey, smoothly being stretched in every direction and in every imaginable yummy color. Or to push the analogy to sexy—it is like taking room temperature butter mixed with some aphrodisiac essential oil such as

ylang ylang and rubbing it into the small of your partner's back. Now *there's* a picture to fall in love with. That is oil paint.

With my first color mixing, I wanted to eat the paints. I felt as if I was back in first grade eating the paste—remember that white stuff that came in the big jars and smelled like bubblegum and goodness? I ate it. Oil paints are the same. It not only feels good mixing them; but, when you get the entire palette spread out they all look so good you want to eat them. Like a tray of harmonizing, glistening, finger-licking, sensual hors d'oeuvres.

Many people have remarked how they want to take a hunk off my paintings and chew it. And, in fact, I have carried that edible paint theme into the titles of some of my work, "Stems and Bubblegum," "Warm Dunes and Taffy," "Hay and Ribbon Candy." {Legal note—oil paint is not edible. Randy Loubier, his heirs and his assigns, are not liable for any harm that might befall, etc.}

This switch to oil paints marked an important win for the artist and a loss for the accountant. Oil paints are more expensive, and this pushed the penny-pinching bean counter back on his heels. Moreover, it opened the door for the artist to eventually develop a lavish, opulent use of paint. Viewers often remark, "You must spend a fortune on paint!" I do. But the result is a unique engagement with the viewer—the texture beckons them to crawl into the painting and explore the canyons and crevices of color, shadow, depth and emotion.

I tried my first oil painting after I got home from the visit with Uncle Dick. "Sunset Over the Inlet." Okay, so it isn't the greatest. But I did have some fun. And clearly, I had learned a thing or two from Uncle Dick.

First, you can see that I learned to apply blue in the shadows to make it look cooler (the bank on the right). Second, I learned that the sky had to be lighter on the bottom than the top in order to give it depth. Uncle Dick took me outside one day to show me the sky for the first time—look at it, and you will see that the bottom part of the sky is lighter than the top. Third, I mixed a palette of colors that I have never used again—I really don't like this palette, though technically they do go together.

The other reason this painting is important to me is that it shows the start of my skies and water techniques. My skies and water have a lot going on in them. The rapid, sometimes random movements in the paint strokes are an integral element of my technique. You can see that this started in the very first six months of painting.

For the remainder of 2001 I still experimented a bit with my genre. "Alpine Garden," "Solace," "Belgrade Lakes Outhouse," "The Lily," and "Sunset Over the Dunes " were perhaps the best representation of where my style was headed. "Herman Maier" was an attempt to use my loose style on a completely different composition. I like the painting and it hangs in my office; but many people remarked that it reminded them of LeRoy Neiman—he painted athletes in this loose style. I decided there was no way I was going to be like somebody else—there's no fun in that. I'd rather not paint at all. I never did another skier, even though I work in the ski business (Atomic USA).

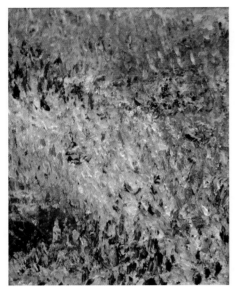

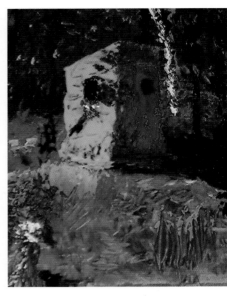

Alpine Garden, Oil on
Canvas, 18x24, 2001

Solace, Oil on Canvas, 18x24, 2001

Belgrade Lakes Outhouse, Acrylic on
Canvas, 18x24, 2001

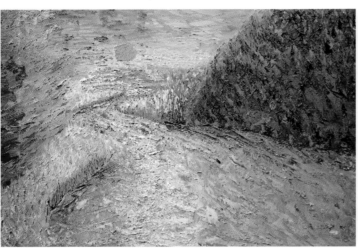

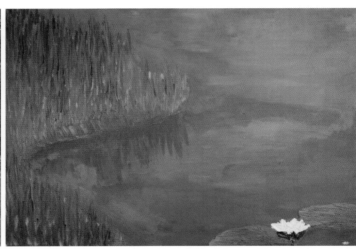

Sunset Over the Inlet, Oil on Canvas, 18x24, 2001

Lily, Oil on Canvas, 24x30, 2001

Hermann Maeir, Oil on Canvas, 24x36, 2001

Sunset Over the Dunes, Oil on Canvas, 18x24, 2001

DON'T LET THE ARTIST OUT OF THE HOUSE

One other important discovery in 2001 was the near disastrous result of letting the artist out of the house. I nearly killed myself one day.

I told you how I love photography. I first explored photography in 1978. I was in the Air Force and living in Japan. I was stationed on Misawa Air Base, way up in northern Honshu, some 12 hours north of Tokyo. The environment was cold, rural, lonely, culturally traditional and conservative. There were four weeks of summer and 48 weeks of cold. Frigid in the winter. This was not far from my roots in Maine—so I was at home with the weather.

But strangely, I was also "at home" with the culture. As soon as I got there, I immersed myself in the local way of life. I ate off base as much as I could afford. I walked around the town of Misawa for hours, just circling the same streets (very small town—so there wasn't much to see). I wanted to see it all, I wanted to taste it all, and I wanted to touch it all. I wanted to knock on doors and invite myself in, but I didn't speak the language.

So, I looked into the on-base extension college and took a semester of Japanese, then another, then another. I practiced as much as I could with the locals and eventually spoke well enough to carry on basic conversations.

I also read every book in the base library. The tea ceremony became a particular fascination. It was an art form—the simple composition of the layout, the almost stark tearoom accented by one piece of art, usually calligraphy of some aphorism. The mixing of the tea is a somber, ritualistic, reverent environment, with the sounds of the koto (a Japanese stringed instrument) tinkling and twanging in the background. The tea itself is also art—the blend of the tea, like any blend of great coffee or wine, is a beautiful art of finding just the right complements so the taste buds are treated to an explosion of opposing flavors that blend into Heaven in your mouth.

The tea ceremony became a symbol for me of the Yin/Yang—it was my first real earthly connection to the theory of balanced opposites. The Japanese flag has the symbol of the Yin/Yang on it. In its simplest form, Yin/Yang is female (Yin) and male (Yang) or hard (Yang) and soft (Yin), or…any number of opposites. But the real understanding of Yin/Yang is a much more profound conceptual vision of life. Life is not a simple black or a simple white. Nor is it just a bunch of shades of gray in between. It is a continual dance of opposites, with one taking the lead in that dance momentarily and the other yielding momentarily. And more complex still, each side of the opposite is thousands of variants, all dancing the glorious dance of life opposite to thousands of variants from the other side, taking partners, exchanging partners, taking the lead or yielding as the moment arises.

There is an optimal balance to this dance, theoretically; but the balance is so fleeting that most of us don't realize it in the moment. Rather than seeking some sort of static balance—which according to this theory is impossible—the idea is to strive to be closer to the balance, continually sensing how far away we are and adjusting ourselves to move toward balance rather than away. And, of course, the closer we are to balance, the happier and healthier we are.

So, coincident with my forays into Japanese culture, I took a photography course. I wanted to capture this culture on film. I bought a very good camera and a hard metal case, strapped it to the back of my motorcycle and took pictures everywhere. A stooped-over woman working the fields, her back curved from the weight of a gigantic bundle of hay. A man with a distant look on his weathered face sitting in a squat, waiting for the bus. A woman sweeping dirt in front of her humble home. Tea gardens, ikebana displays, and tattered brown kimonos. Shinto shrines, Buddhist monasteries, cherry blossoms, and sake glasses raised together.

Most of the photos were bad—I was happy to get one that I loved on each roll. Ahh, but that *one*. That *one* made me very happy. I craved the feeling of the great shot. It was addictive. I used a lot of film in the two years I was in Japan.

I developed a sense for composition, which came back to me years later when I started painting. Once I understood the fundamentals of composition, I figured out how to look for them through the lens and quickly click the shutter before they moved. Put the center of focus in one of the four intersections of the thirds (divide your frame into thirds by drawing two lines down and two lines across—where the lines intersect is where your center of focus should be). Make sure you have lines of movement for your eyes to follow that will take them *through* the photo, not out. The lightest part of the photo will create a center of interest—a stronger center of interest if the lightest and the darkest parts are next to each other ...

So when I started painting I had already spent 23 years developing my sense of composition and, therefore, I didn't have to think much about how I wanted to see the finished layout. And with my photography experiences, I had also developed a thrill of the creative moment.

But, and this is a very big but, the *big* difference for me between photography and painting was in the length of the creative process and how deeply I was getting into the right brain. When I was taking photographs, I would meander around, look at various angles, pause and shoot. I did my best to get a good shot—but even taking my time to get a good photo, the artistic process was very quick. When I started painting, I found that I was in this other brain thing so deeply that I was in a fog. I noticed that when I was "in the zone," deep in my right brain, I lost some faculties.

Time. No idea how much time just went by—could have been 15 minutes, could have been 3 hours.

Sense of bodily functions. I wasn't hungry, I wasn't thirsty.

Where I was in space. Actually, I was in space. The wind could have blown the rest of the house down around me and I wouldn't have noticed.

I realize that I have just described most of my accounting and engineering comrades. I can hear wives all across the world shouting—that's my husband!!! Yes, I have experienced all these problems deep in the left brain, too. It took me most of my life learning how to come out of the focused left brain enough to be socially aware when it was appropriate, and then dive back in when no one else was around.

However, I am telling you, the right brain is different. This right brain thing *feels* different when you are deep in it. It is more ethereal, less weighty, less heady, more emotive. It is, without a doubt, just as debilitating as some of the left brain zones I had been in—but very different. It is deep in the Yin.

I had spent my whole life functioning in and out of focused states of left brain activity. Indeed, it was how I jettisoned my career as a young college graduate—I could get deep into the left brain and pull out some amazing junk. And, eventually, I had also learned how to look up from my spreadsheet when my employees came into my office, or pay attention to my wife when she came into a room. I had learned how to get myself out of the depths of the left brain when I needed to multitask (that's a bit of a lie—I still can't multitask very well, but I try.)

So while I had become comfortable getting into and out of my left brain quickly and safely, I had little experience in understanding the depths of the other brain. I found that the real danger, in the fall of 2001 as I delved into the right brain much deeper than I ever had, was that I didn't know when or how to get out of it. One day in October 2001, I left for work a little early so I could stop on the way and take some pictures for possible paintings. I live in New Hampshire and the fall foliage is beautiful. Furthermore, I am surrounded by gorgeous bogs and marshes that are spectacular in every season.

I stopped at the first bog and delighted in the view. The sky was autumn azure, the sun was auric ochre, and though early in the day the trees were having dinner—starting with pumpkin soup, then poached salmon over spinach, butternut squash in a cranberry maple glaze, and finishing with raspberry tart and banana cream pie. It was spectacular. I got out my camera and started taking pictures. After a couple clicks, I noticed images of paintings coming to me. I saw photos through the lens, but saw paintings in my head. I kept going, snapping shot after shot. I felt great. I was in the zone. I saw images everywhere—perfectly composed, *finished* paintings.

Ten minutes later, I got in the car and started driving. I drove along Walnut Hill, a tiny, meandering, 20 mph road. The slow pace was great because I was seeing more images as I drove. Look left—yeah, look at that barn, snap the shot in my head and see the painting. Look at two o'clock, snap the shot in my head; and see the painting of the gnarled apple tree against the rock wall. Everywhere I looked, there was another great shot, another finished canvas.

I made my way down the hill to intersect Route 101, a 55mph two-lane road. At the stop sign, I looked right and saw more beauty—more photos and paintings in the little marshy area. Man, I thought, this is great. I was higher than the pines. Life couldn't get better than this.

I pulled onto Route 101. About two miles further is a scene that I have always loved. It is just fields and trees and a hint of a house behind maples and oaks that jetty into the main field. I love the roll of land, the shapes, the colors and the old tattered fence line in front. In the spring, a temporary marsh in the foreground reflects the beauty behind. In the fall, the colors of trees are brilliant, particularly in the evening, as the

low golden sun hits them. In the winter, the house is more exposed, contrasting the warmth of home and hearth against the cold snow along the lonely fence line.

A fabulous display of my hometown, this is what I love about New England. But on this particular October day, I nearly lost all right to paint. I looked to my right to see the scene—I knew it was coming; I see it twice every workday.

This time, however, I saw the scene in full palette and I saw the *brush strokes*. I saw big bold knife marks making the background, and colorful strokes of grasses and fence line in the foreground. I felt my hand making the dabbing strokes of sleepy trees against swizzled sky...

I heard the honking before I saw the flashing of the brights. I "woke up" to find I was driving perfectly straight down the wrong lane at 60 mph directly towards another panicked driver.

You know how sometimes you drive along, lost in thought and suddenly realize you don't remember the last mile or so; and you appreciate the "auto-pilot" as an amazing thing. This was different. I had lost all contact with the world momentarily. I was beyond autopilot—I was pilotless, back in the studio, painting.

I had gone in too deep, at the wrong time.

I swerved, avoided the crash, saw the wide open eyes of the woman driving the car as she swerved as well. We both managed to stay on the road. I pulled over, but she drove away—perhaps with coffee stains or worse all over her clothes.

As I pulled off the road, the accountant accosted the artist. You stupid son of a b--- You see what you are doing? Do you? Are you proud of what you are becoming? You are ruining us. Do you hear me? You are ruining us. I am a damned fine driver; I have never caused an accident—I haven't even had a speeding ticket for 20 years. This painting baloney has been going on for a year, and lately, I haven't said much but you know I have hated this stuff from the beginning. You are such a moron. You can't even drive now!

I was shaking. I really had screwed up, and I felt terrible. I had to leave the artist home. I really *had to leave the artist home.*

2002—SETTLING IN TO A STYLE

In 2002, I only jumped off onto one tangent—figures. Other than that interesting but short-lived foray, I settled into landscapes done in the highly textured style I had developed the previous year.

However, the painting technique of managing the texturing was a significant focus for me. I experimented with different ways to use the palette knife—pushing, pulling, punching, large sweeps, short sweeps, edges, flat side, base, tip, sizes of knives, shapes of knives. I tried loading the knife with tons of paint, and I tried just a little

paint. I tried mixing paints on the knife before the sweep, and I tried mixing paint on the canvas with the sweep. I tried using a smooth base coat of paint, and I tried using a rough base coat of paint. I tried letting the base coat dry and I tried leaving it wet. All of these combinations created hundreds of variations that were quite interesting to me.

But throughout it all, I am happy to say these experiments of texturing were directed by the right brain. I wasn't using a scientific process to compare one technique to another. For example, I didn't set up two paintings side by side and deliberately change the painting process to see the difference. The experimentation was loosely managed. If I felt like using a heavy base coat on the painting, I did. I might dislike the painting in the end, but it didn't stop me from using a heavy base coat on another painting. I did what I felt like doing, each painting, from beginning to end. When I finished, if I liked the painting, it stayed. If it was terrible, I put it aside and turned to the next painting.

The right brain, along with my emotions on a particular day, determined what and how I painted. I eventually decided which techniques I liked best and which didn't work for me. But it was a slow evolution, played out over many, many paintings. I loved the process. Indeed the process continues today. I still paint the way the mood strikes me—with a loose foundation of historical successes and failures influencing that mood.

By 2002, the accountant rarely interrupted the process. During my painting sessions, the accountant was gagged and tied. I painted. I just painted. There was no thinking. No worrying about what someone might think. Just painting. One after the next. The images would come to me during the evening or morning and I would paint them. When they were complete, I went on to the next—not a lot of lingering—just keep on going.

Uncle Dick had suggested I not linger between paintings. He had said that the best way to learn to paint was to paint. The best way to find your voice was to sing, as much as possible. In my first two years of painting, I am not certain how many canvases I covered, but it was well in excess of one hundred.

I painted every spare minute. You can imagine my life was already full. I have a demanding job as the number two executive for a sporting goods company. Furthermore, Judy and I have a blended family of six children who are active in school, sports and social lives. It is a busy life.

Therefore, what I found during 2002—and it indeed continues today—is that I would often be in the studio for 15-20 minutes, and be interrupted by someone needing help with homework, or some other activity. Therefore, I would be painting in my right brain, leave for 20 minutes of left-brained math homework and have to shift back to the right after returning to the studio. At first, this was frustrating. But sometime in 2002, I perfected this switchover. From minutes to seconds. Feel the shift, and go. Feel the shift, and go.

During 2001 and 2002, I visited many galleries. I studied the art to see what others were doing. And eventually, out of curiosity, see what others were selling. I didn't

have any interest in selling my work, but after numerous visits, I started to develop a curiosity about what type of art was successfully being sold. As I looked around, I realized that I actually liked my work better than nearly everyone else's work out there.

Now this statement really has to be explained—carefully. I didn't believe my art was better, more developed, more artistic, more refined, more educated, more expressionistic, more *anything*. I just *liked* mine better. Remember, I was going through this huge transition in myself. I was learning to express my preferences on canvas. Moreover, I was learning how to allow myself to create from my soul. The artistic process for me was a visceral translation of passion and desire, interest and love, to a canvas. No schools, no methods, nobody telling me what to do, just me standing in a room blurting out images through passionate strokes of a palette knife.

I am very aware of how much hard work most artists have put into their schooling. Believe me; I spent years in school getting my bachelor's and master's degrees. I then spent years of additional training to be the very best manager possible. So, I will never minimize the traditional artists' path and commitment to their profession. And therefore, it is with the humblest intentions that I made the comment above, that I just liked my art better than most other artists. The only other person I have made that comment to was my wife, because I was certain most people—particularly other artists—might have good reason to take offense if I didn't take time to explain.

But don't we all like our own children better than we do other people's children? It's normal. How many of us have witnessed their own child doing something silly and considered it funny—but if the neighbor's kid did the same, it might instead be irksome. It's natural. The runny nose on your own child is not that big a deal—but it is wholly unpleasant to see on another child.

Now when I go into a gallery that has my paintings hanging, I go to "spend time with my children." They are my offspring. I love them. I miss them when they are gone. I visit them and wish them well. I give them hugs and kisses (when nobody is looking of course; I wouldn't want to freak anybody out—grab the kids, Martha, there's a weirdo in here). Some children are born to go out into the world, others must stay for a while before they are ready, and others will never leave home. The ones that stay are breakthroughs of some sort that I must keep—there is too much of me in them to let them out of the house.

Interspersed with visits to other galleries, I also returned numerous times to Expressions Gallery to see the owner. Diane had framed my second painting, "Sunset Over Autumn Pond." She had been curious to see me again, so when I first went back to her gallery we chatted about my art. Thereafter, each time I returned I would describe what I was working on and she would say, "Hey, if you get a chance, bring it by, I would love to see it." Diane knew I was not an artist by profession and she knew I had started painting because I *had* to. I assumed she was just being polite.

I was reticent to take any paintings to Diane—it was difficult enough to share some of my experience with her verbally. My fear was that she might not like my art. Only family had seen my paintings and they all love me—so they were either supportive or neutral. In particular, Judy and my parents were beyond supportive—they were

cheerleaders. Always positive, always picking out new favorites, always giving me great feedback I so desperately needed in those first few years. Stepping out to Uncle Dick had been difficult, but I trusted that his relationship to Judy would somehow keep the atmosphere supportive.

Stepping out to Diane was a whole other thing. She seemed like a nice person—but she works in the art business, and with that has to come the mental toughness to weed out the less desirable art.

In the fall of 2002, two years after I started painting, I somehow found the courage to take her some of my art. We set up a time to meet in her gallery. This was a big step and I was feeling very exposed. I can remember the conversation with myself on the way over to the gallery.

The accountant started. "What in the world are you doing? You made a pledge to me that you were painting for yourself. Nobody else. Just you. Just *you*. So, why on earth would you want to take your art to have someone else look at it?"

"But this is just sharing. Nothing more. She seems like a nice person."

"No, this is not just sharing. This is a gallery owner. You don't even know this person that well. Sure, she seems nice, but what is going to happen when she throws up all over your crap? Huh? What are you going to do then?"

"I don't know."

"You don't know a lot these days. That is the problem with this art junk—you know nothing. You just 'do it.' The idea of just doing something without thinking makes me sick. It makes me sick. Are you listening? Sick. Sick. Sick. And you promised me you would not go public with this crap. You are going to embarrass me."

By 2002, however, the bantering between the artist and the accountant was taking a turn. There was still the push and pull going on inside me as I worked through the vulnerable feelings of stepping through Wonderland's door. But the artist was learning to reason with the accountant. "Oh just let it go. What's the worst that could happen? Think about risk—you like to think in terms of risk—what's the real risk? So she hates it. I still like it. Judy likes it. My mom and dad like it. And did I mention, *I like it*. That is all that counts. *I like my art*. So what if she doesn't like it? I go back to painting for me."

I walked in and said "Hi" to Diane. She was with a customer and told me to bring in the paintings and put them "over there."

Okay, I thought, easy for you to say. Reason and emotion were wrestling inside me. I tripped over the door stoop on the way back to the car. Then I fumbled with the keys and set off the car alarm. *Ughh*!! I really am a moron, I thought. Oh my God, just get in the car and leave. I got in the drivers seat. I took a deep breath. I looked over my shoulder at my inspirations. They were in the back seat, looking out the window like children who had arrived at Six Flags.

No, I am not going to leave—I am taking these in. I love them. They want to see the world. Diane is going to see these paintings. Go. Go. Go. Before you *think* any more.

Diane had asked to see three paintings. I had a difficult time whittling it down to three—by this time my house was brimming with paintings—so I had brought five with me. I can't remember exactly all five paintings but I know that "Alpine Garden" and "Through the Trees" were in that first bunch. And I know that I had purposely brought in three others that represented other tangents. I had reasoned that I should show her several styles—to share the breadth of work spanning two years.

She finished with the customer and came over. We made some small talk. Then she looked at the paintings.

"Wow, I like these, Randy."

Yup, I thought, she is nice. Nice lady. She is going to let me down easy.

"Wow. Hmmm. Different styles going on. Now these two," she pointed to 'Alpine Garden' and 'Through the Trees.' "Do you have any more like these? They have a similar style and I like them."

"Actually, I have a whole house full of them." A bit of an exaggeration, but most of my work was in this style. It was the style I had developed over the past two years, alone in my studio—full texture, large strokes, loose composition.

"Do you think you could bring in five paintings in this same style?"

"Yeah, sure, I could." I flushed with molten excitement. Wow, I was thinking, this woman is a goddess. She actually likes my paintings. I am so happy. I can't stand it.

"So, you finally let me see them. Thanks so much for bringing them in for me to see. If you bring in five in that same style, I would like you to consider letting me hang three out of the five of them. Would you consider this?"

Oh boy—the excited part of me was thinking, what are you nuts? Of course I will let you hang them. I couldn't believe my ears. I was going to hang in a gallery. This was crazy. It was fantastic. It was unbelievable. Wait till I tell Judy. Wait till I tell my mom and dad. Wait till Uncle Dick hears. This is so amazingly incredible.

The accountant was conspicuously quiet. The artist simply answered, "I would love it."

I went home and told Judy the great news. She was ecstatic. Then I called my mom and dad. They too were overjoyed. Sharing my successes with my family has become a pleasure in my life. There is no substitute for someone you love supporting you, wholeheartedly, unconditionally, enthusiastically. No substitute. I know that not everyone has that support. I count my blessings every day.

I returned a couple of weeks later with ten paintings. Yes, I know she said five, and any good accountant would have followed the rules. Take five, you moron, Diane told you five, not ten. Yeah, but these are all great—if she doesn't like them, she can tell me. The artist was really taking over now.

She loved them all. Really. She did. I now know that Diane wasn't just being nice. She really did like the paintings. I didn't know what Diane thought at the time, because the accountant would never have let me believe her anyway; but Diane tells me that from the moment she first saw my work, she knew it would be successful. "I had you pegged early on. I may own a gallery in a small town where art is not as appreciated as it is in some other places. I am here because this is where my family is. But, I know great art when I see it—I know what people like in art. And, I knew your art would resonate with people the moment I saw it."

Diane decided to keep all ten paintings and hang them. We agreed on frames and she ordered them. She said it would be a number of weeks and, "I will call when I have everything ready."

Close up of "Danish," Oil on Canvas, 8x10, 2004. Photo taken from an angle with reflective lighting to show texture.

Several weeks later, Judy and I went to a local art show. The show was being held at a recently overhauled Victorian bed and breakfast. The owner of the B&B had joined forces with seven New Hampshire artists to showcase a grand re-opening by featuring an art event. It was a brilliant idea—the patrons would view the artists' work in one large room and then tour the B&B. Judy and I had seen the advertisement in the local paper and decided to go.

The artists' work was in the great room of the house. We took our time viewing the art, and eventually decided to tour the house. Judy went through the doorway, into the next room. She looked back to say something to me and stopped mid-sentence, "Oh my God, *look*!"

I turned to face the wall. "Through the Trees" was hanging there, framed, and with a sign with my name, the name of the work, the medium, the size, a price, and a statement that the art was courtesy of Expressions Gallery, Milford, N.H.

My knees went weak. My face flushed. I didn't know what to do. I stared at it. Damn, it looked good. But what had happened? How could this be here? Why hadn't Diane told me?

Then, oh my Lord, the crisis hit me—my art is hanging where others can see it. And there is another couple coming through the doorway; they are going to see my art. Oh, shit! Whoosh ... I was back in school, at the chalkboard, being asked to show the class how to divide a fraction. Everyone is staring at me, I have to pee and I don't want to mess this up. Randy, now don't be shy, you had the highest grade on the test and I want you to show the class how to divide a fraction. I am shuffling my feet and staring at the chalk rail. I can't believe this witch has me in front of the class—if this is what I get for getting the best grade I'm not making that mistake again. Whoosh ... back at the B&B. The couple came through the doorway, glancing back at my painting.

They stopped, and stood next to us looking at my creation. Not a word. Not a damned word. Nothing. Just looked for 30 seconds and moved on.

What? That's it? Gesumm! Nothing to say about it? That is my heart and soul in that painting. You have any idea what I have been through to create this flippin' art? You have any idea what it is like to *be* a dweeb accountant and then *fight* the dweeb accountant and come out on the other end with any sanity whatsoever? Huh? Do you?? You have no freaking clue what I have been through. The least you could do is whisper, "I kind of like that." Anything would have been better than nothing. Give me something!!! You *hear me*!!!!???? Give me *something*!!!!

My heart was racing. I felt an asthmatic wheeze coming on. I reached out to Judy and touched her. I needed some stability.

Judy was beaming. She was smiling ear to ear. She was practically dancing. She couldn't stop moving. She couldn't stop exclaiming—what she was saying I don't remember—but it was all good stuff. And in between each exclamation was a happy squeal.

I thank God for Judy every single day. When I touched her, I was able to breathe better and connect with her excitement.

We then went into the parlor and there on an easel was "Lavender." One of my all-time favorite paintings. One of those paintings I regret selling. Whoever owns that painting, God bless you, take care. In fact, call me and let me know how she is, would you please.

Finished in a beautiful gold frame, "Lavender" perfected that Victorian parlor. It seemed as if the B&B had commissioned me to create this piece.

This time, my heart just stopped completely. No worry about what someone might say. I just melted in the presence of the painting. Melted. Somebody came in and remarked to their partner about the painting. I didn't hear what they said, but it was something favorable because the reaction was a pleasant, agreeing, "uh huh."

There was a third painting there as well, though I can't recall what it was.

I left the show wearing a smile that lasted for days. I couldn't believe my art had been on display, and we had "run into it" by happenstance. After thinking about it, I decided I was glad it was a surprise. In some ways, it made it easier on me—I didn't have to worry what it might be like to stand in front of my art as a viewer for the first time. It just happened.

Within a few months, Diane had sold all ten of the paintings. More than she had sold of all the other artists combined. I took in more and she sold those, too.

2003—MY FIRST SOLO SHOW

Once my paintings started to sell, I realized that Diane, Judy, and my mom were right all along. Their contention was that if I loved my art, and they loved my art, other people were bound to see its value. This was not logical to the accountant in me. Just because you like doing math doesn't mean people will want to hire you as a mathematician. It had been my mantra that had kept me going: "I am painting for me."

In the end, neither corner of the boxing ring won. There was no need to think logically about it; and there was no need to hide behind the statement that I am painting for me. People just liked my art. Not everyone. We all have different tastes. But in general, people liked my art.

I continued to produce a lot of work in 2003, painting with every free moment. That summer, Diane decided she needed to give me a show of my own because my work was doing so well. She set a date of November 8, 2003.

I was excited. But I didn't know quite what to expect. I have been in business a long time so I am comfortable in a room of business people. I can drink a martini and laugh at small talk as well as anyone. I can put on a great board of directors presentation, give a speech to hundreds, and lead many layers of management. However, the idea of having people stand around and look at my art, while I shuffle my feet, was disconcerting. So, I wanted to ask Diane what to expect.

When I joined the military after my first year of college, I was the perfect candidate for the recruiter. I walked into the recruiter's office, explained that I wanted a technical career, told them I had graduated from Deerfield Academy (a prep school in western Massachusetts), needed college money and what did they have available?

Through the Trees, Oil on Canvas, 11x14, 2002

Lavender, Oil on Canvas, 20x30, 2002

The recruiter looked at me, and said, "We have all that and more, son. You want a technical career, we got that. You want college money, we got that. And you can see a bit of the world as well. Are you available on September 9th to take a trip down to Texas for basic training?"

"Yup."

"Well, let's get the paperwork going then, son."

Later that night I was thinking about some of the logistical issues. I needed to clarify some things. So I made a list and called the recruiter the next day.

"Sir, can you tell me what people do with their spare time down at basic training? I mean, should I bring a bathing suit? Is there a gym with a pool? And how about laundry soap? Should I bring that? And when do you get to do your laundry? Is it at night after class? How many guys are there to a room?"

The consummate military man never broke rank, not a smile, as far as I could tell. He just answered my questions with a "Son, the Air Force has it all figured out. You don't worry about a thing. All you need to do is show up, and we'll take care of everything."

After a couple of days in basic training, and fearing for my life every time I heard the "click, click, click" of the Sergeant's shoes at two o'clock in the morning, I remembered my questions to the recruiter. I can't imagine how he avoided laughing.

That experience was underneath my question to Diane about the reception for my art show. Obviously, the task was simple—stand around and answer questions about my art if anyone asked. What I really needed to know, *but there was no way to ask*: what about the emotion of it all—how do I handle the emotion of standing in a room full of my art, which is emotional enough for me as it is, with a bunch of people there to admire my creations? Will I just break down and cry like a sissy? Will I get sarcastic and smirk a lot? Will I put on a mask and act cool? Will I use a sophisticated Deerfield face and act slightly elevated?

You might wonder, why not just be me? But who was I, anyway? Was I still the accountant, or was I this new guy, the artist who had been locked up in a 12 x 12 room for three years? Worse yet, what would happen if I turned the artist loose in a room full of people?

I thought about this for several days. The relationship between artist and accountant had matured over the past three years. The vulnerable feelings that fueled the banter were still there. But as I imagined what it would be like to be at my first solo show, I found the accountant saying to the artist, "Don't worry about it. We can do this together. If we collaborate, we will have a terrific night. I will handle the suit, the smiles and the pleasantries, and you handle the questions about the art. Together we have it nailed. Let's get it done."

It turned out to be a fabulous night. It was a night I will never forget. People were congratulating me and extolling my artistic virtues. I had no problems being me—some amalgamation of me. Once the night got going, I just couldn't stop smiling. Ten paintings sold in two hours. Two people tried to buy the same painting within minutes of each other. All I did was smile, and say thank you, thank you so much, you are so kind, thank you, I know—can you believe this was inside all these years, yes I really am an accountant, thank you so much, you are so kind, thank you.

I was euphoric.

Diane was jubilant. No artist had enjoyed a reception so successful at Expressions Gallery—a small town gallery, remember.

By the time 2003 was wrapping up, I realized that I *had* to branch out to some other galleries. I knew by then that my art had to move farther out into the world. This was not the accountant thinking—it was a visceral feeling, the soul talking.

The accountant, of course, had the facts down—by the time 2003 was finished, just 14 months after I decided to let my art out to the world, 32 paintings had sold. My Web site was taking 300 hits a day, and the response I was getting from everyone was consistent.

"I feel great."

"Your art makes me happy."

"I love the texture. I want to touch, eat, or be in those bunches of paint."

"I want to dive into your canvases—there is something in there that is special for me—like you painted this just for me."

"I love your colors and the way they play together on the canvas."

"Your art is unique, but not so unique that I can't hang it."

"It feels so alive."

"I love the movement of the paint."

"It changes character depending on the light—in daylight it is lively and energetic—at night it is thoughtful and spiritual."

"My eyes dance through the painting."

"I feel terrific just being around your work."

"I can't believe you are an accountant. I wonder what hidden talents are in me."

It wasn't the facts that were convincing me to reach beyond Expressions Gallery. Facts are deceiving, said the artist; the truth is, we are making people feel good with

art. That is the reason. Moreover, the story is getting to people. It is encouraging people to reach out beyond "themselves." To see what else is inside, compelling them to go beyond the boundaries they set for themselves. We need to go out into the world.

Diane was supportive. She knew all along that I was going to have to move beyond her gallery. But we talked about it numerous times. I kept bringing it up. Diane had been so good to me, and I couldn't bear to think that she might feel I was being disloyal. I owed Diane so much, but I needed to get my art out to the world.

2004—EXPANDING THE REACH

I started 2004 with a goal. I wanted to get into another two to four galleries.

You have to understand something. The accountant had long ago done the math—there is little money in being an artist. Believe me, the accountant did the spreadsheet. By the time you pay for paint, canvases, supplies, frames, backings, hanging materials, packing and freight to ship art back and forth between galleries, and pay the galleries between 40 and 70 percent, there is no money left. For all but the upper reaches of pricing, you are lucky to be in the black.

The accountant knew that pursuing additional galleries would create more work than value. Therefore, I didn't start out 2004 thinking I wanted to get into two to four more galleries because I wanted to make money. The accountant already realized this wasn't in the cards. The artist, the visceral Yin, however, had a different goal.

I *had* to keep painting—I didn't have much choice. Therefore, I needed to keep selling my paintings—they had to go somewhere. And they would. That still wasn't the goal, though—that was just a premise.

The goal was to spread the message. My art comes from somewhere deep, and it makes people feel good. We all have something inside of us. Get it out. Let it go. Free it up. Find it. Spread it. Give it up. If you have already found it, bless you. If you are still looking for it, keep looking; it is in there, and bless you for looking.

In the first weeks of 2004, I entered a member's exhibition at one of the nicest galleries in New Hampshire, The Sharon Arts Gallery in Peterborough. A beautiful gallery with a great reputation for fine arts and fine crafts, set in the center of a quaint, artsy, quintessential New England town. My entry, "Conversation With a Bog," sold within minutes of opening to a woman from Virginia. The replacement, "The Iris Garden," sold within another two weeks to a couple from Texas.

I applied shortly after that to be juried into The Sharon Arts Galleries—to be a full member with rights to sell in their member's gallery; and I was juried in. The gallery manager, Susan, and the assistant manager, Laurie, took an immediate interest in my art and decided to shoehorn me into an already stuffed calendar of shows for 2004. That was in June, and the show was a wonderful success.

In March of 2004 a gallery in Wisconsin, The Flying Pig, a beautiful gallery on the shores of Lake Michigan asked me to sell through them. In May, a gallery on the historic town square of Leesburg, Virginia, The Left Bank, contacted me to sell my work because they had seen the article on me in Art & Frame Review magazine. And Yankee Magazine, a monthly publication with two million readers, contacted me to do an article on my story. I had met the goal for 2004 in May, and that got me thinking....

THE BOOK THING

It was mid-2004 when I got the idea that a book would be another vehicle to spread the message.

I don't know much about the world, about life, about art, about anything. Certainly nothing that I am willing to argue with you about. I have my ideas—but I know they are my ideas, not yours. I am not suggesting that you do anything differently with your life. I am not suggesting that you be anybody else.

I just wanted to share my story, in the hopes that it might precipitate something, somewhere. I have been through an experience that has elevated my faith. In what, I am not certain, but more faith in something. Perhaps the science of the brain. Perhaps GBA (God/Buddha/Allah—I see the roots of all the major religions as one). Perhaps the resolute nature of the human race. Perhaps the power of unconditional love. Perhaps the adaptable nature of our species. Perhaps....

I don't know. I guess, when you really get to the heart, it just is what it is. And whatever it is, it is very powerful. It is so powerful that I felt compelled to share my unworthy, wholly inadequate words about it.

The Hindus have a concept that I like. Chit and Prana. I occasionally take courses at Kripalu, a wonderful educational center in Lennox, Massachusetts. I tell my employees that Kripalu is the "groovy" place I visit so I can remain calm when all Hades is breaking loose at work. In 1998, I was taking a course on breath-work and meditation when an instructor pulled me aside. She said she wanted to warn me not to get too deep into the Prana, without balancing my life with Chit.

"But I love the Prana," I replied. "And what is Chit?"

"Yes, I can see you love the Prana, most of us love the Prana, but I noticed it took you a long time coming out of that meditation and I thought I would share a story about balance."

So she told me a story about when Kripalu had been started by a Hindu guru and his mentor in 1966. Long before it converted to an open educational center, Kripalu had been started as an Ashram—a yoga based monastery. The guru and his mentor set up the building and the facilities, and the mentor went back to India. Four years later, the mentor—who had been hearing terrible stories of the facilities in disrepair and the organization in tatters—decided to travel back to the United States to see what had

happened. He walked in to find everyone with tired but smiling faces, and deep, distant looks of love and dizziness in their eyes—and the place was a mess. Meals were being missed, the grounds had not been kept up, the bathrooms weren't clean—it was a disaster, logistically. He immediately saw the problem, and met with the local guru in his office.

"You forgot the balance. The Prana is good. Your sessions of chanting and music are great. However, you have forgotten the Chit. You must teach your disciples balance. Allow them the opportunities to feel the wonders of expansive energy, the Prana. But you must give them the balance of the equally wonderful contractive energies of the Chit. Yes, let them have their music sessions, but then do not allow them a Pranic meditation; make them do a Chit meditation, so they can sleep. Then ground them more in the morning with more Chit as they eat and prepare for the day. Get them to value the Chit in the details of their daily work as much as the Prana in their other activities.

"Your disciples must learn that spiritual growth is found in balance. Each side is a vessel—each vessel pours into the other. If your Prana vessel is bigger and you pour into the Chit vessel, it spills out. You must exercise both regularly to allow each to expand and eventually when they are both large enough you may find enlightenment. But you cannot find enlightenment exercising just one vessel."

That story impressed me. Right or wrong, it seems to fit my meager attempt to understand life a little better. At a minimum, it made me feel good about my own balance. When I told the instructor about my profession, she was immediately relieved—the daily life of a business executive would certainly balance the Prana, she had said. Then she added with a laugh, "Just don't quit that job!"

So, will the accountant and the artist balance each other? Can we ever really find that balance? Would we know it if we did? Will I be a better accountant if I am a better artist? And vice versa?

Better yet, will this book mean anything to you? Am I hitting any notes, striking any chords? Will you be a better engineer because you read this? Will you, the professional artist, be compelled to find the accountant in you?

What is it inside or outside of us that creates great art and great science? Is it the same thing? What … ? Is … ?

I guess in the end … it is … what it is.

However this book got to you, I am glad it did. I wish you well on your journey.

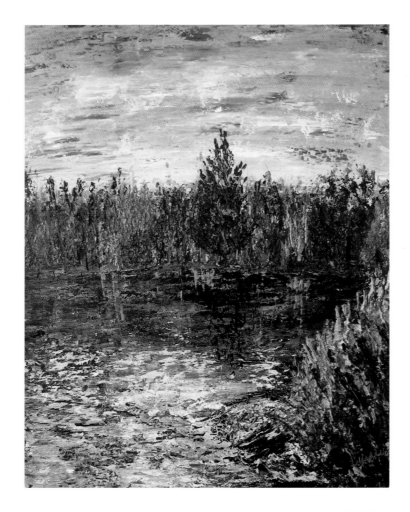

My wife's family has a cabin on Long Pond in Belgrade Lakes, Maine. Wonderfully rustic with no electricity, it is one of my favorite places. One blustery weekend in October 2001, we went up to close the camp for the winter. I took along my acrylics, my French easel and a few canvases. I brought everything down to the dock and quickly sketched the scene to the right of the dock. This painting is the oil version that I did back in my studio from the acrylic sketch. Maine must be seen in October. In the meantime, this painting may explore for you the contrasting chill of the air and water with the full on blazing heat of the sugar maples, oaks and birches.

Autumn on Long Pond, Oil on Canvas, 18x24, 2002

Sonoma, California, is one of my favorite places on earth. Especially in the fall, the crisp air is filled with the smell of crushed grapes. These grapes were just days away from being picked to make a bottle of cabernet sauvignon. In this painting, I tried to capture the passion of the wine to come.

Wine In Time, Oil on Canvas, 11x14, 2002

My wife and I honeymooned in England in the summer of 2002. The beautiful rolling hills of the moors in southwest England stunned me. From the tops of the hills, we saw endless walls of hedges running haphazardly. In this painting, I tried to capture the peaceful feeling as I witnessed the grace of this land.

English Moors, Oil on Canvas,18x24, 2002

I love the look and smell of the salt marshes. Here, the lazy marsh winds its way to the sea. Big bold strokes taken with a palette knife create a robust image.

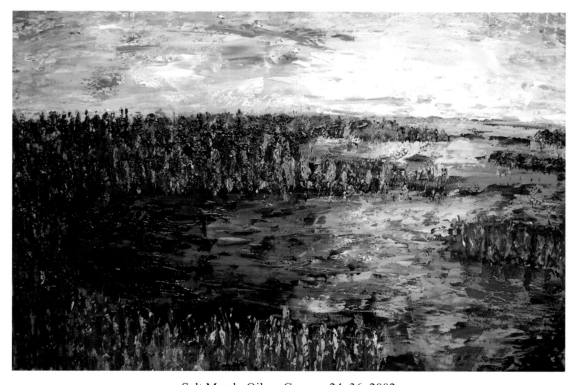

Salt Marsh, Oil on Canvas, 24x36, 2002

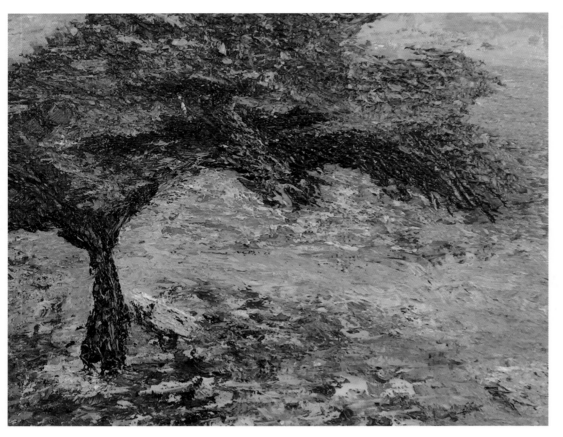

The setting was high above the rolling moors in Blackmoor National Park. The vista was spectacular, with just enough chill in the air to make you realize you were in England. Trees, rocks, and sheep were scattered about--the land was somehow both comforting and desolate. One tree in particular struck my fancy. It was misshapen from years of prevailing winds. The flow of the tree, the life of the tree, was what captured me. Through that patient steadfastness, the tree created a wonderful, peaceful space under it—a place I enjoyed sitting for a few moments to enjoy the view.

Windswept Tree-Blackmoor National Park, Oil
on Canvas, 18x24, 2002

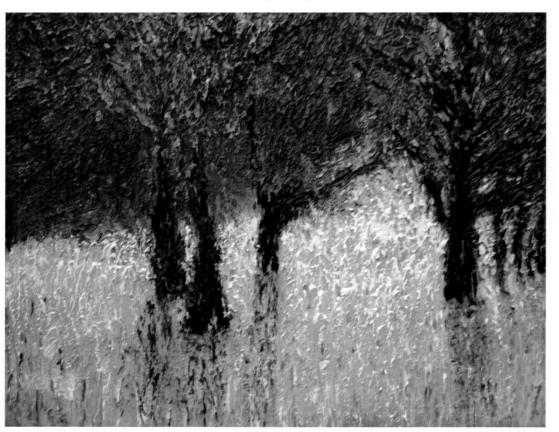

The hills of Sonoma are filled with fields and scattered oaks. The light shining through the opening in the trees captured my attention. This painting remains one of my wife's favorites and graces our home.

Sonoma Oaks, Oil on Canvas, 18x24, 2002

A small stand of Redwood trees, about ten of them in all, fairly close together. Under the trees, it felt like a little protected hideaway. One evening I captured the last rays of the sunlight as it came in from a low angle, through the base of the trees.

Redwood Light, Oil on Canvas, 8x10, 2002

Birch trees are a great part of the New England landscape. One day I was driving through the White Mountains of my home state of New Hampshire and I stopped at a quiet little pond. It was dusk, the ground was covered in snow, and the pond was partially frozen. Numerous stands of white birches led into the pond. It was a spectacular setting. I knew the lighting may be too low to capture the scene but I thought it was worth the effort. Two dozen shutter clicks and two hours ride later, I arrived home and downloaded the images into my computer. Disappointing--very, very blue. Then it occurred to me--paint the blue. Paint it anyway. That was the image, so paint it. I loved the first painting so much, I ended up doing a series of three. This is the second--and the most colorful of the three.

proud Lady Birch
looks straight ahead
naked all winter
among the manly pines.

Ed Marshall

Moonlight on Birches 2, Oil on Canvas, 8x10, 2001

My Short-Lived Exploration of Figures

Blue, Oil on Canvas, 18x24, 2002

Judy, Oil on Canvas, 18x24, 2002

Speaking From the Heart, Oil on Canvas, 18x24, 2002

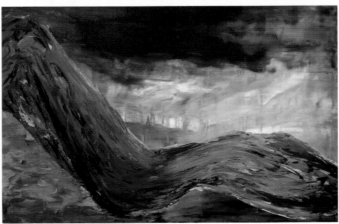

Venus, Oil on Canvas, 24x36, 2002

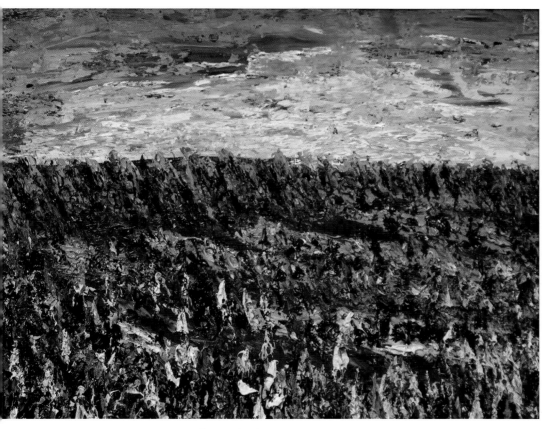

The vineyards of Sonoma are magical places. Particularly those up in the hills. There are back roads in Sonoma that lead up into the hills. The roads wind around through fields, houses, and vineyards. The smells change from eucalyptus to manure to crushed grapes. This scene, vividly captured in this painting, was on the road to a quiet B&B tucked back into the hills. Minus camera and paper/pen, I actually sketched the basic image on my PDA for later translation. Lots of color and lots of passion.

Sonoma Vineyard, Oil on Canvas, 18x24, 2002

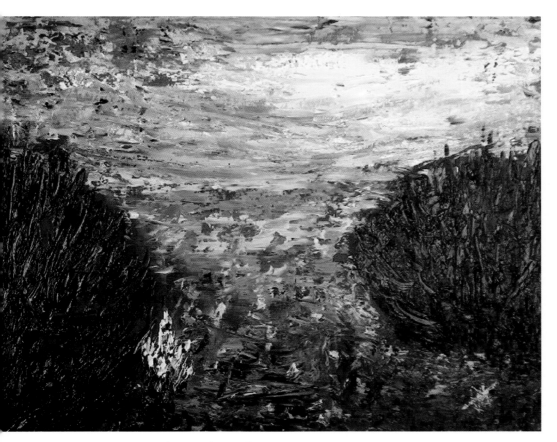

A quiet meadow near sunset. Soft colors contrast the boldness of the palette knife strokes to produce a lively, yet peaceful scene. My wife and I stayed at a remote B&B in England. It was right on the ocean in the south of Cornwall. The vistas over the ocean were spectacular, but what really captured me were the pastures and meadows. We arrived late the first night and hoofed it across the meadow, through cow patties and all, to the local pub for some dinner. The light was fading as we crossed the meadow. Can you fall in love with a field? The ocean was beautiful, but it was the land, the earth, the history of that dirt, that I felt passionate about right then.

The Meadow, Oil on Canvas, 18x24, 2002

My mom's flowers are on the right, my dad's raspberries on the left. Like two old time Yankee farmers who love what they do—mom doesn't touch the raspberries, dad doesn't touch the flowers. Now, if you know anything about raspberries, it is that they spread through their roots. The roots grow underground and then pop up more shoots above ground. Does this look like a recipe for tension? It keeps them busy.

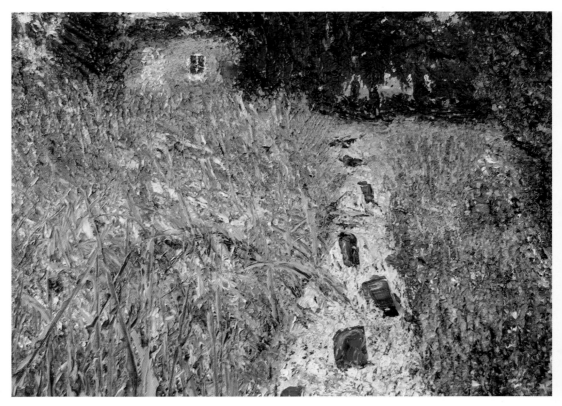

The Raspberry Shed, Oil on Canvas, 18x24, 2003

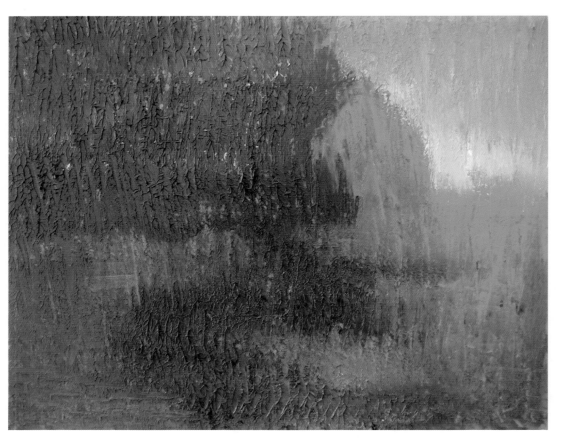

Barns are a common site in my home town of Amherst, N.H. Those first rays of light, when the sounds of the day are just starting, are captured here in a dramatic, nearly all red, painting. The dew is on the grass and leaves, the sky promises a bright early summer day, the scent of morning coffee and bacon drifts towards me.

sloping old barn off
on the hill the wind
took your paint and
made you beautiful

Ed Marshall

Morning Light at the Barn, Oil on Canvas, 18x24, 2003

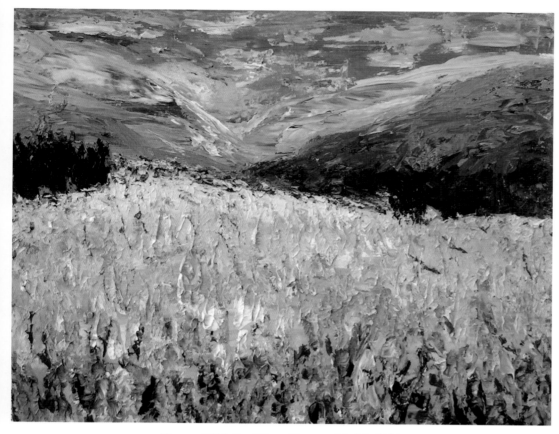

Hay and Thistle, Oil on Canvas, 18x24, 2003

From the collector after they received Hay and Thistle, "ummm..... ahemm.....errr.......I'm shocked! The painting is fantastic, fury and feeling on canvas, almost becoming a part of the viewer, leaping from its woven base to interact with any life that gets near. What an artwork! Randy, you lie when you hide behind that accountant countenance, for we know what you truly are ... a painter, a mad dasher, somehow wielding a force at the end of a palette knife, yielding to direction that would send most spinning wildly out of control, like a novice down the Matterhorn. I don't know what to say. Unbelievable."

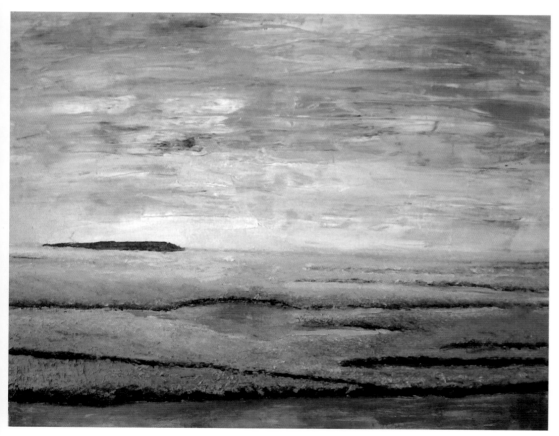

Autumn Saltmarsh, Oil on Canvas, 24x36, 2003

This image came from a photograph of the salt marshes in Massachusetts. I tried to capture the vast expanse of the marshes as they finally make their way out to the ocean. The time was late October, after the grasses have turned golden. The scene is peaceful and done with less texture than I normally paint with---still with the palette knife and still textured, but less so. This one barely made it out of the house—it was one of Judy's favorites.

As you may have been able to tell, I love trees. I am truly a tree hugger—literally. I like the feel of trees. They are warmer than everything else around. Ever notice in the winter that the snow at the base of the trees melts first? The trees capture the sunlight and radiate the heat. This painting took many months to finish. I kept going back to it to add dabs of paint here and there. I couldn't quite get it right for a long time. Then one day, I walked into the studio, knew instantly what I wanted to do, and in a few more strokes it was finished.

Impressions of a Forest, Oil on Canvas, 11x14, 2003

Springtime in New England is characterized by blustery days, with alternating warm and cold air streams (sometimes in the same minute). But, this was one of those days when the air was still, and it was gloriously warm. The air smelled of freshly made twig. Just a few trees were still begging for their leaves to get completely out in the world. The light coming across the meadow, through the branches of the trees, and into the water was what I wanted to capture.

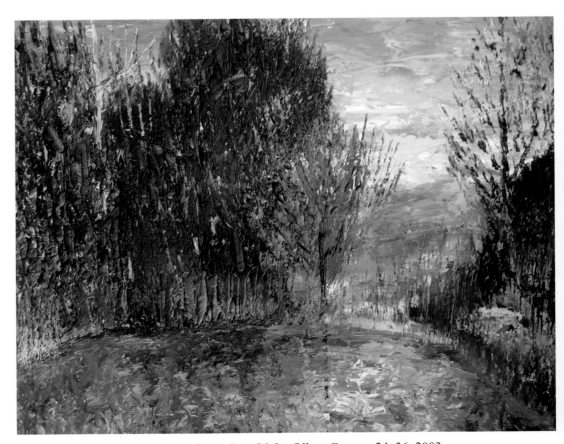

Spring Meadow—Last Light, Oil on Canvas, 24x36, 2003

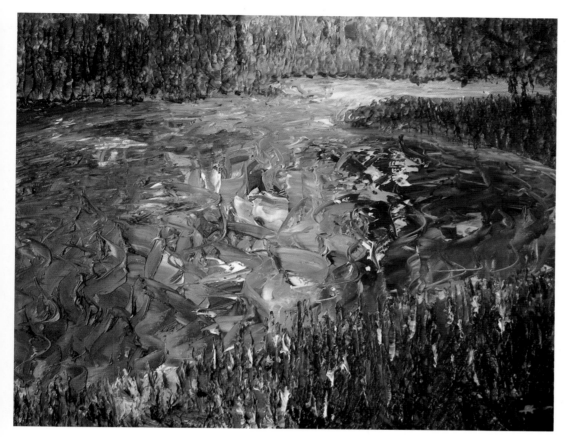

This was an image that came from my mind. I lived in northern California for four years and I used to visit the Russian River. I guess this scene could have been from nearly any river, nearly anywhere. But somehow it reminded me of a scene in the far reaches of my mind on the Russian River in California. The colors— passionate purples, turquoises, and reds—are accentuated by large bold movements of the palette knife.

Russian River, Oil on Canvas, 24x30, 2003

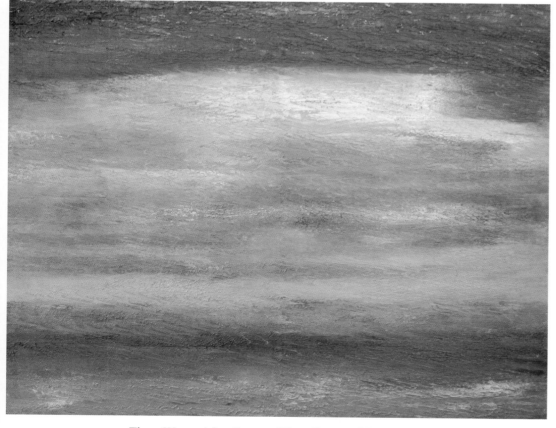

The three waves at the bottom of this painting show softly against the magnificent sky of this post sundown ocean scene.

little gray gulls
pulling up
pushing down
making waves

Ed Marshall

Three Waves After Sunset, Oil on Canvas, 24x36, 2003

I often wonder what it would be like to be a tree. Some trees have the best views in life. Imagine sitting where this birch tree sits every day, watching what this birch tree watches every day. The peace, the calm, the splendor, the pure serenity of life as a birch tree.

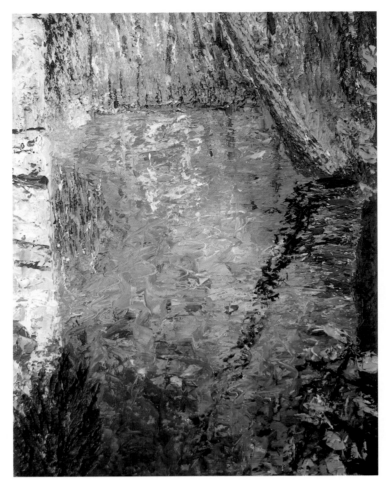

Birch View, Oil on Canvas, 24x30, 2003

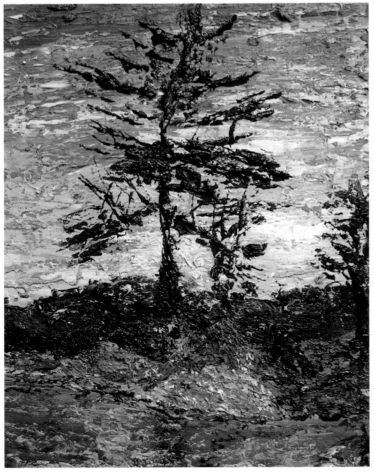

Just off shore from the family cabin in Maine is a tiny island. One day, late in the fall, I took the camera in the kayak and captured a shot of the island. One of the things I love about this painting is the contrasting chill of the water with the warmth of the sky and tree. The truth is while the water was very cold that day, so was the air---the wind had picked up, and the sky was not as warm as my painting shows. But the warmth in the painting is my emotion for the region, the island, and that wonderful crooked top pine tree.

ancient tree
scarred long ago
some heal
some don't

Ed Marshall

Long Pond Pine, Oil on Canvas, 11x14, 2003

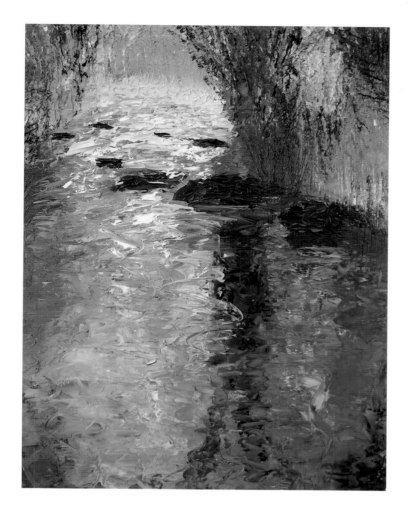

Just another day at the brook. Peaceful sounds of the water flowing over and around the stones. The play of light in the water, making reflections of everything glorious about life in New England.

boyhood brook
golden summers
so much dust
you sparkle still

Ed Marshall

Red Tree at the Brook, Oil on Canvas, 24x30, 2003

The wide cuts on the leaves on the left made me feel this was somewhere south of the Mason-Dixon line. This is another image that woke me up in the morning and had to be painted.

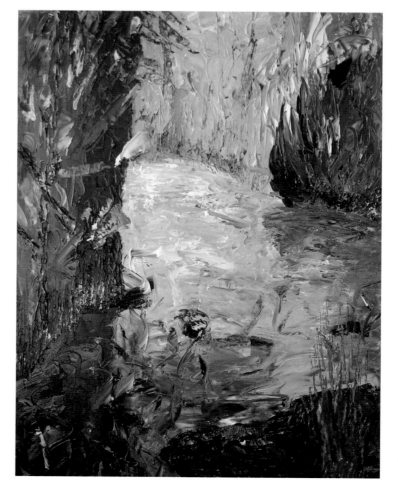

Southland, Oil on Canvas, 24x30, 2003

Conversations With a Bog

I don't know exactly when I first connected with a bog. But it most certainly was as a young boy growing up in Maine.

From an early age, my father and grandfather would take me hunting. Curiously, I never liked the hunting—what I liked was the waiting, the sitting quietly. We would sit at the edge of a bog, on the side of a field, or in a tree. Listening. Quietly.

I was supposed to be listening for sounds of game. But, at first all I could hear was the wind rustling the leaves, or the trickle of water over the rocks. Then I would listen to my breath and my heartbeat. Soon my mind would wander to numerous boyhood things—the Neatsfoot Oil I recently put on my baseball glove, the incredible snag I made at shortstop yesterday, or Mary Peck's pretty blonde hair.

After some considerable time of mind wandering, I would return to the present and look closer at the scene. It became absorbing to really see the scene—the grass reeds coming up out of the water, the spots on the lilly pads, the incredible reflections off the water.

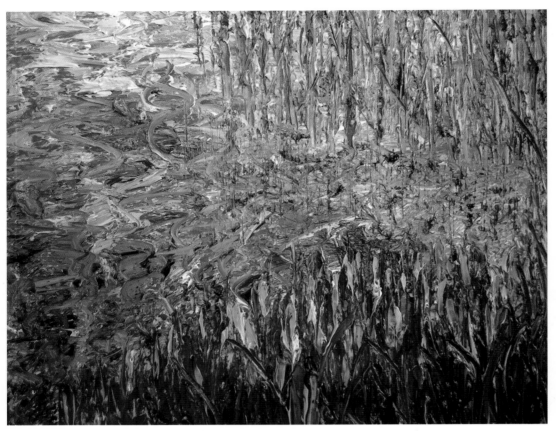

Second Conversation With a Bog—Sit With
Stillness, Listen, Oil on Canvas, 20x24, 2004

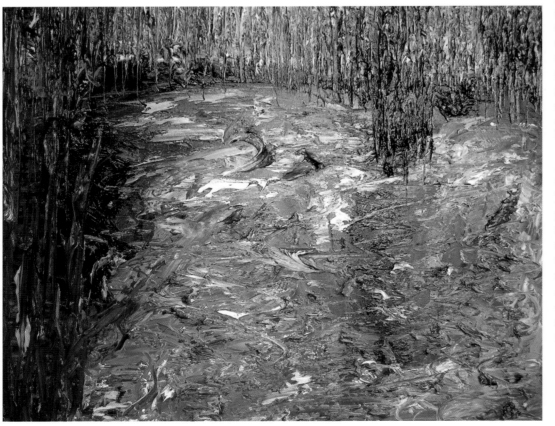

Third Conversation With a Bog—Seek Stillness Where
There Isn't, Oil on Canvas, 20x24, 2004

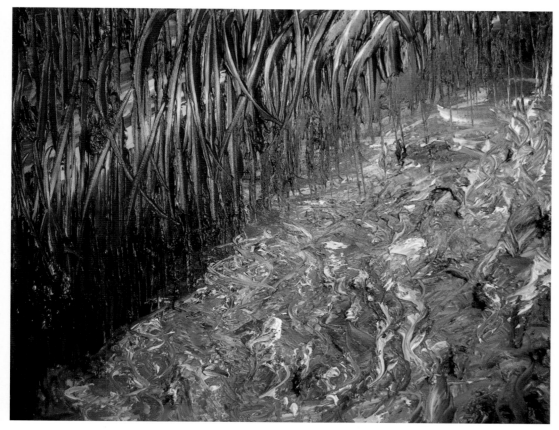

Fourth Conversation With a Bog—Your Yin, My
Yang, Teamwork, Oil on Canvas, 20x24, 2004

I found myself entranced by the scene—the smells and radiating heat from the grasses as they are warmed by the sun, contrasted the coolness, the peacefulness and the activity of the water giving me a spectacular light show of reflections. I didn't realize until I was a senior in high school that these were my first meditations, my first conversations with a bog.

The lessons from those conversations shaped many of my views—that it is important to sit quietly now and then, that inspiration can be found in those moments and that the best things in life exhibit complex simplicities—glorious harmonies of opposites like the stillness *and* activity of the bog water.

The Conversation With a Bog Series is my humble attempt to capture the thoughts, feelings, and wisdom of the bog. The harmonies of color, the passionately painted water next to the quietly painted grasses. This is as close as I could come to sharing those conversations through the voice of my art. If you wish, sit in front of these paintings. Listen. Quietly.

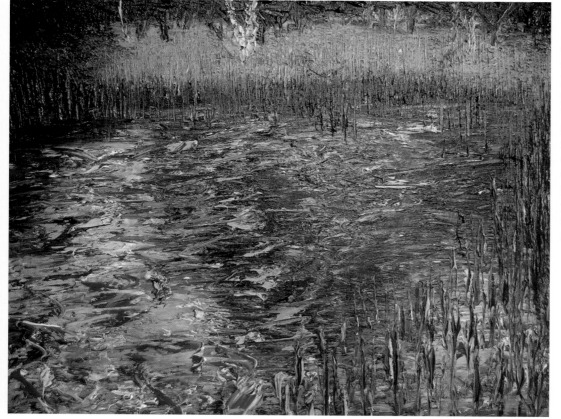

Seventh Conversation With a Bog—There's Magic in the
Twilight, Oil on Canvas, 20x24, 2004

twilight's edge
stars at my back
silhouettes fly
between silhouettes.

Ed Marshall

I took this photograph on Mother's Day, 2003. My brother flew in from LA, my sister flew in from Albuquerque and we surprised my Mom and Dad by showing up on their doorstep and taking them into Boston. It was a great day, not just because of the fun we had surprising my mom, and strolling through Boston Public Garden, but for the incredible photographs I took which became paintings later on. This became one of my favorites. There is more detail in this painting than is typical for my style, but the muse inside wanted the detail so I went with the moment.

Mother's Day, Oil on Canvas, 24x36, 2003

My first 36 x 48, with a beautiful broad gold frame, this painting commands your attention. Exceedingly heavy from the many, many tubes of paint on this canvas, the strokes of the palette knife in the trees pop right out of the frame at you. And you can smell the cold, fresh water as it bubbles over the rocks.

Twins, Oil on Canvas, 36x48, 2003

I completed this painting as one of three choices for a couple who had hired me to do a commission. One of the other two looked better in their living room. Judy and I both love this painting so it currently hangs in our three season porch. Each of these tulips have a complete palette knife full of paint.

Good Soldiers, Oil on Canvas, 24x36, 2004

A classic field of red poppies.

French Poppies, Oil on Canvas, 11x14, 2004

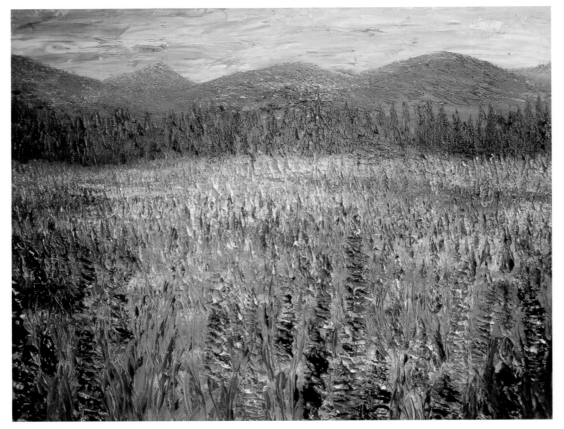

From a
photograph a
friend of mine
took of Sugar Hill,
New Hampshire.
It is just north of
Franconia Notch
in the middle
of the White
Mountains.

Lupine on Sugar Hill, Oil on Canvas, 30x40,
2004

These large Irises
are singing in
harmony.

Singing the Blues, Oil on Canvas, 11x14, 2004

My wife grew up outside of New York City and spent summers in Maine at a cabin on Long Pond in Belgrade Lakes, Maine. Just 6 years ago the cabin was only reachable by boat and still today has no electricity. Unbeknownst to us at the time, when Judy and I were both young, I was living just 30 minutes away in Waterville. A small world.

Blueberry Island is just off shore near Judy's family cabin. Our kids have slept out on Blueberry Island and, small world indeed, my father slept out on Blueberry Island when he was a child.

A Visit to Blueberry Island, Oil on Canvas, 20x24, 2004

My art discovers balance.
Tension, relief, balance.
Excess, minimalist, balance
Yin, yang, balance.

This painting was an experiment—to take my art to a limit. This very large canvas is exceedingly heavy with paint. Many, many tubes of paint are on this canvas. The excessive paint is balanced by the simple composition. It is subtle and overwhelming.

Autumn Birch, Oil on Canvas, 30x40, 2004

My mom is an outstanding gardener and Irises are her favorite. This painting of her garden is full of paint! Big luscious strokes of pure French Ultramarine paint make up the irises.

The Iris Shed, Oil on Canvas, 16x20, 2004

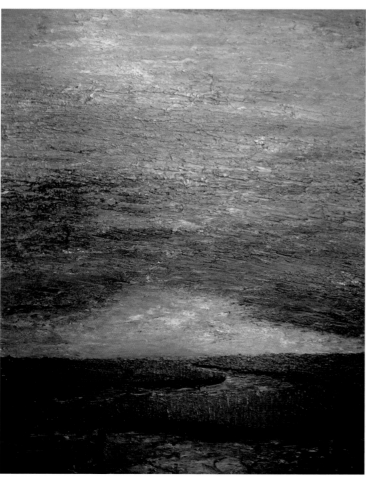

I live just an hour from the ocean. There are times I feel a need to get to the ocean to see and smell the salt marshes. They are special places with interesting eco systems and fantastic vistas.

This painting was done with relatively light texture—a dabbing movement with the palette knife. It really captures mood. During the day the sky is fairly bright with the sparkling of the light coming off the millions of facets in the texture. But at night, under normal household lights, the eye is immediately drawn to the light in the low sky coming across the grasses to the skiff.

old wooden boat
tied in the bay
twice a day
she changes her mind

Ed Marshall

Moonlit Skiff, Oil on Canvas, 30x40, 2004

The reds in this painting, difficult to reproduce in any media, are brilliant shades of raspberries. The concept for this composition came from a book I was reading on the ecology of volcanic zones. It seems that nearly every photograph I see now I am gauging my reaction to it as a possible painting. It is an interesting way to live—always looking at a scene to see if it produces a visceral reaction, a catalytic response, a precipitating emotional mandate to create a new painting. Rarely does the painting have but a passing likeness to the photo; but if the response is there, I react to it and translate to canvas my feelings of the scene.

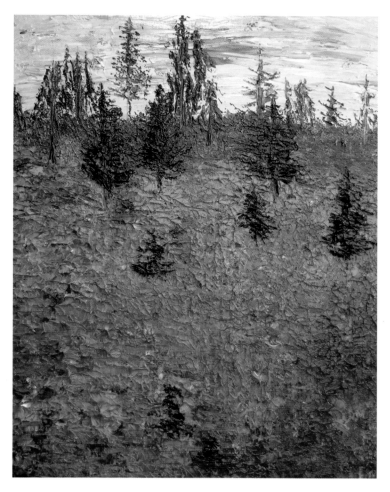

Huckleberry & Pine, Oil on Canvas, 20x24, 2004

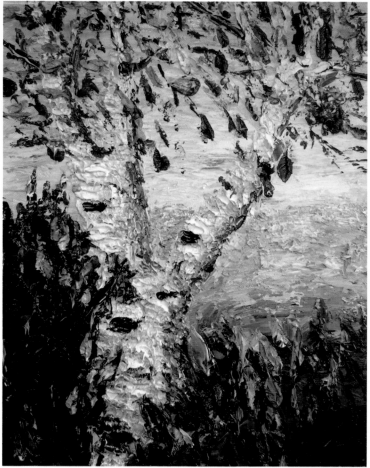

The old birch stands
Proud above the few
Next to the meadow
Of honey and dew.

The Old Birch, Oil on
Canvas, 24x30, 2004

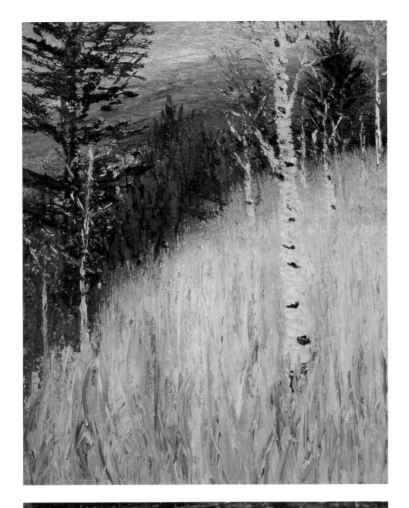

We have a mountain in New Hampshire called Grand Monadnock. Even by New Hampshire standards, this is a relatively small mountain. But it is beautiful and the centerpiece of the gorgeous Monadnock Region. In the 1800's the mountain had become overrun with wolves, so the locals burned the mountain. The vegetation on the top of the mountain never recovered; therefore, you get the feeling of being above timberline at a relatively low elevation.

This painting came to me in one of my morning visions. After I finished the painting and stepped back from it, I was reminded of one of the scenes on Monadnock—part way up, looking through the trees to rural New Hampshire

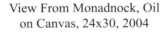

View From Monadnock, Oil
on Canvas, 24x30, 2004

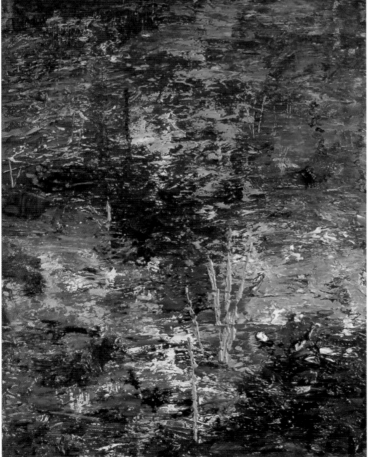

I took a photograph of the inlet waters feeding Horace Lake in Weare, NH. The photo was spectacular. I could hardly wait to translate this photograph to canvas as soon as I got it into the studio.

16th Conversation With a
Bog—See Through, Oil
on Canvas, 20x24, 2004

15th Conversation With a Bog—Move With The Tide, Oil on Linen, 10x20, 20x20, 10x20, 2004

19th Conversation With a Bog—You'll Know it When You See It, Oil on Canvas, 12x36, 2004

slender green reed
sun silvered ripples
hold on tight
mr. dragonfly

Ed Marshall

20th Conversation With a Bog—Let Harmony,
Oil on Canvas, 20x24, 2004

Is there advice in the bog?

Could it possibly be that if we let go, a little harmony would appear all by itself?

Should we walk in the rain—is it cleansing—is it possible we might find some answers between the drops?

21st Conversation With a Bog—Take a Walk in the Rain,
Oil on Canvas, 20x24, 2004

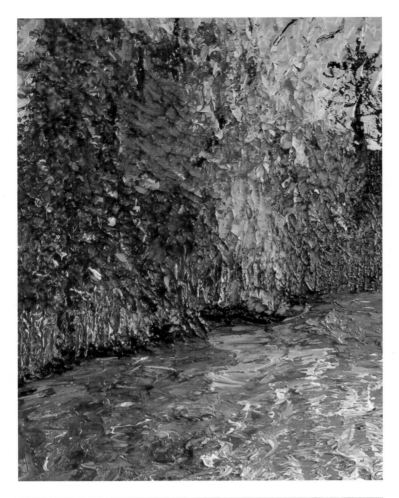

I realize I have a bias, but I think that the colors and textures of New England autumn can best be experienced on canvas through the style of painting I have developed. In the day, this painting will reflect daylight over the millions of facets in the textured paint, much like the morning dew-covered leaves. In the evening this painting is more soulful and introspective.

18th Conversation With a Bog—Warm the Waters, Oil on Canvas, 20x24, 2004

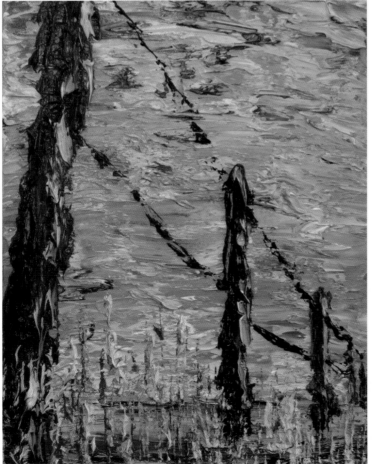

I lived in New Mexico for four years. I had the pleasure of riding the fences with a cowboy friend one weekend. He taught me a lot—humility for one. The ranch is a lonely place if you can't find company in the land. He did. His humble cabin was a one hour ride by 4 wheel drive from the entrance to the ranch. 50,000 acres was his responsibility—and he was alone. We've lost touch since—but, now and then, I raise my glass to you, Reggie.

Caramel Skies Over the Ranch, Oil on Canvas, 11x14, 2004

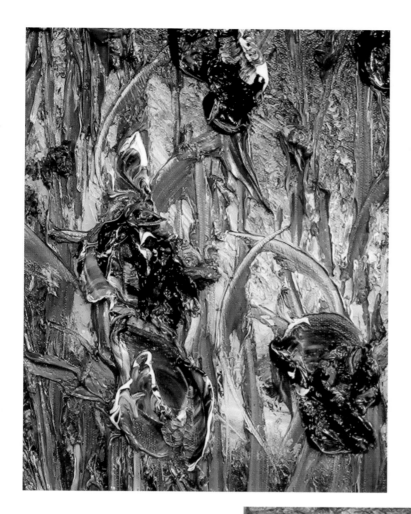

the sun and the moon
can't agree
on the color
of my garden

Ed Marshall

Iris Garden, Oil on Canvas,
11x14, 2004

In 2004 I enjoyed a phase of
painting flowers. I must have
painted 20 paintings over a
couple months—just flowers. I
love the way the petals, created
with a full palette knife of paint,
pop out of the canvas.

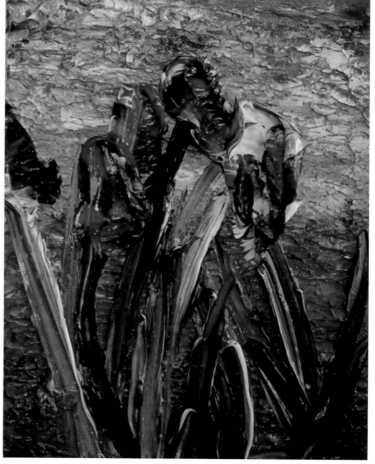

Petals of Passion, Oil on Canvas,
11x14, 2004

There is an old railroad
bed in Amherst, NH. It
is full of outstanding
vistas of bogs and nature.
I enjoy running on this
trail and often take my
camera. Many of my
paintings come from
scenes I have captured
on film from my jaunts
on this trail----and later
translated to canvas.

Birch by the Path, Oil on
Canvas, 18x24,
2004

Another
image that
woke me up
one morning.
This painting
seems like
it belongs
in a baby's
room above
the crib. It
is happy,
colorful and
cheery.

Hay and Ribbon Candy, Oil on Canvas, 20x24, 2004

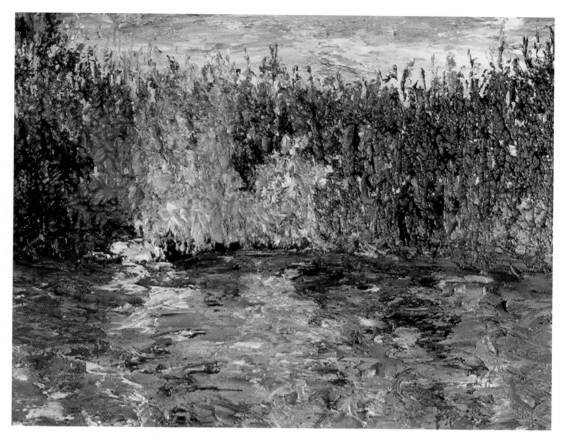

Another photograph I took from the kayak on Long Pond, Belgrade Lakes, Maine.

Crisp air.
Warm sun.
Evergreens
And leaves of fun.

Belgrade Lakes Autumn, Oil on Canvas, 20x24, 2004

My first commission. This hangs in a home with a very long room that provides a great view of the depth in this painting. From a distance your eyes are drawn through the garden and out to the back light beyond the trees.

Red, Red Lips, Oil on Canvas, 24x36, 2004

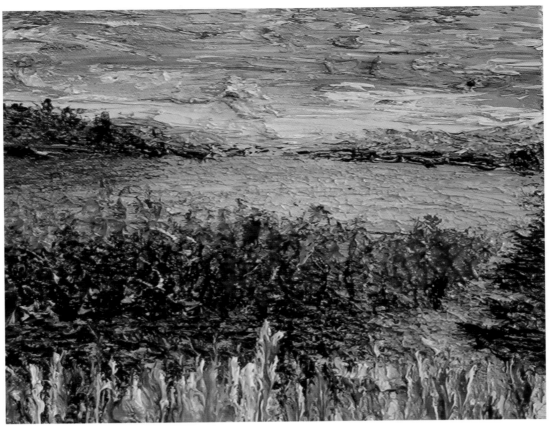

Autumn Countryside, Oil on Canvas, 8x10, 2004

concert tonight
woodpecker
tuning
the pines

Ed Marshal

Warm Dunes & Taffy, Oil on Canvas, 11x14, 2004

Great wine is one of the clearest examples of balance one can physically experience. It wasn't until I lived in Northern California, and had the opportunity to explore the vineyards frequently, that I truly understood that wine is not only art, philosophy, sun and earth, but indeed living breathing Yin/Yang.

Strong statement. Not so sure? Taste great wine slowly—suck in air through the wine in your mouth and see how many flavors you imagine. Pepper? Blackberries? Earth? Raspberrries? Vanilla? Trees? Cherries? Chocolate? Melon? Of course, there are only grapes in the wine. But the real art of wine is in having all these strong, seemingly opposite flavors (who puts pepper on their raspberries?) blend together into an overall pleasing palette. I call this concept "complex simplicities." Together they blend into a glorious harmonizing dance of opposites. Yin/Yang.

Grapes with Wrath, Oil on
Canvas, 11x14, 2004

Passion of midnight
Autumn's stolen vine
Lavender Spirits
Tokens of thine

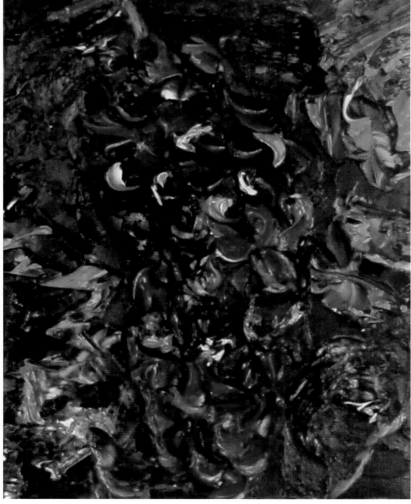

Midnight Grapes, Oil on
Canvas, 8x10, 2004

heartless stranger
autumn wind
seduces each leaf
and never stays.

Ed Marshall

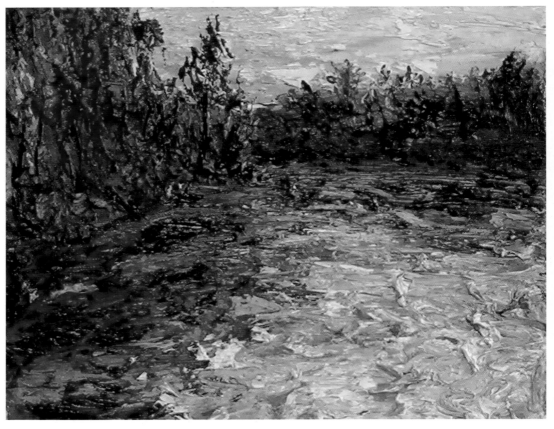

Windy Autumn, Oil on Canvas, 11x14, 2004

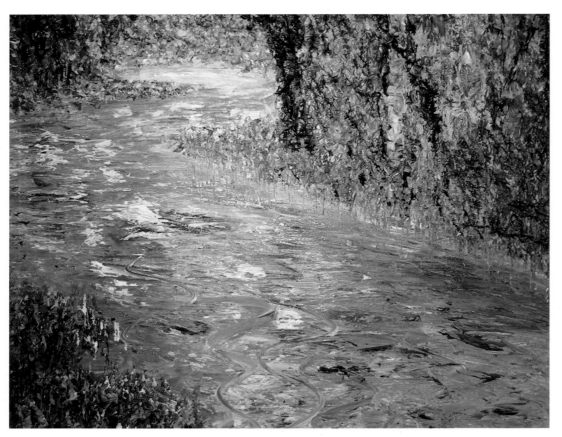

Lively and full of color, this scene of a brook came from an image in my mind. I have spent so much time in the woods of New England, backpacking and hiking, that this could be any brook, anywhere in Maine, Vermont, New Hampshire or Massachusetts. You can make it your brook, if you want, but I can guarantee there are trout in it.

Trout Corner, Oil on Canvas, 20x24, 2004

Spring Birches, Oil on Canvas, 20x24, 2003

One of my lighter techniques, this painting is a soft reminder of the glories of spring. The white birches go through a short stage of red buds. Then the small birch leaves push their way out into the world to absorb the light. This was a misty, rainy day, 55 degrees—my favorite spring weather. A perfect day to dig in the garden or take a walk, smell the fresh air, and wonder.

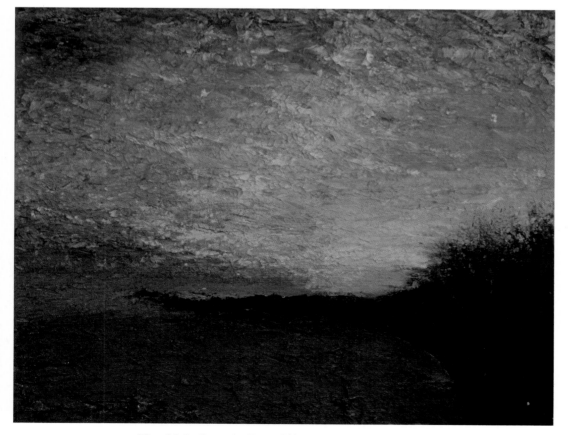

First Light Over the Jetty, Oil on Canvas, 11x14, 2004

I grew up in numerous towns in New England. One of them was Cape Elizabeth, Maine. So much of my love for the ocean comes from the times of my youth, smelling the sea air, listening to the Cape Fog Horn as I worked at The Lobster Shack or walked Crescent Beach. This scene, not of any particular jetty that I can remember, woke me up one morning and just had to be painted.

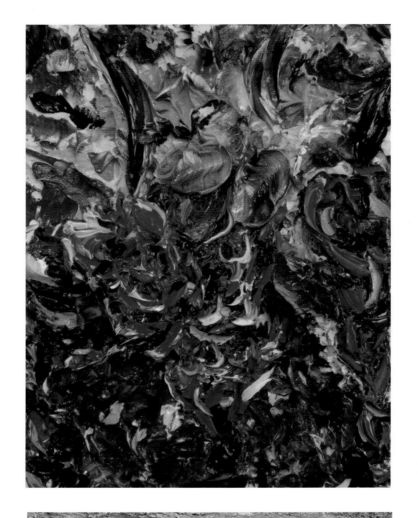

wild grapes
on a dare
I taste them still
zing!

Ed Marshall

Before the Wine, Oil on
Canvas, 11x14, 2004

I have only been
In the Mojave once.
I didn't see Irises.
Artistic license.

Iris Mojave, Oil on Canvas,
11x14, 2004

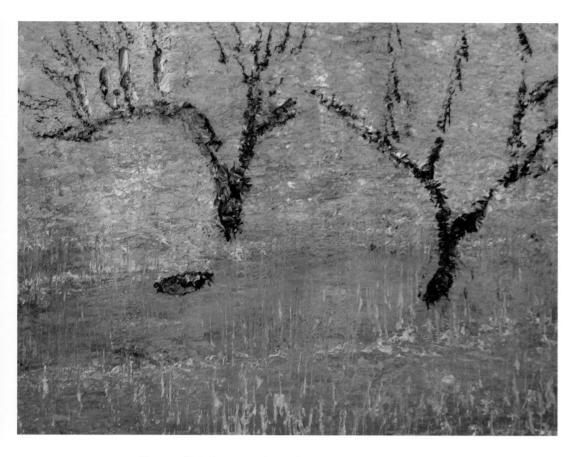

There is a scene that I love at the corner of Pond Parish Road and Spring Road in my hometown of Amherst, N.H. An old sheep farm, rock walls, and scraggy trees. One early winter morning, with a beautiful mist rising from the ground, I sketched the scene on the back of my lottery ticket. I had no other paper in the car and I didn't have my camera with me.

The lottery ticket didn't win, but...if you can feel the depth of the land, the strength of the knurled apple trees, the warmth of the ground against the cool air then I guess it served its purpose.

Sheppard's Misty Morning, Oil on Canvas, 20x24, 2004

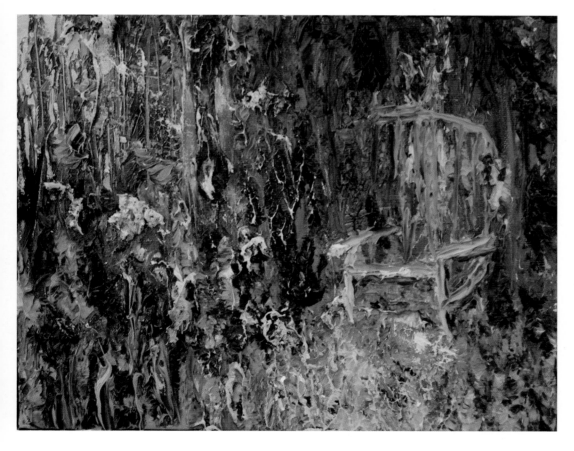

A broken cane chair beside the road. What thoughts were thought from that chair? What decisions were made? What babies were snuggled? If the chair falls, does the man fall with it? Regrets? Who fell?

rummage sale
family album
buried beneath
old Life magazines

Ed Marshall

The Fallen Throne, Oil on Canvas, 8x10, 2004

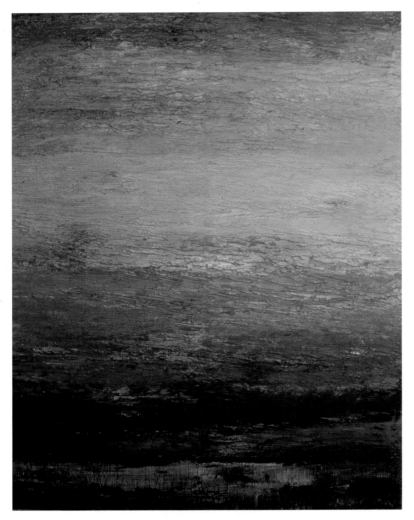

Desert rains are refreshing, but when I first moved to New Mexico, I found them strange. In New England you rarely get the long vistas across open land, so the idea of seeing a storm coming from so far away was intriguing to me.

from the east
the comforter
drawn up gently
by loving hands

Ed Marshall

Storm Over The Pecos, Oil on Canvas, 30x40, 2004

Fog, Down Past Kelly Brook, Oil on Canvas, 24x30, 2004

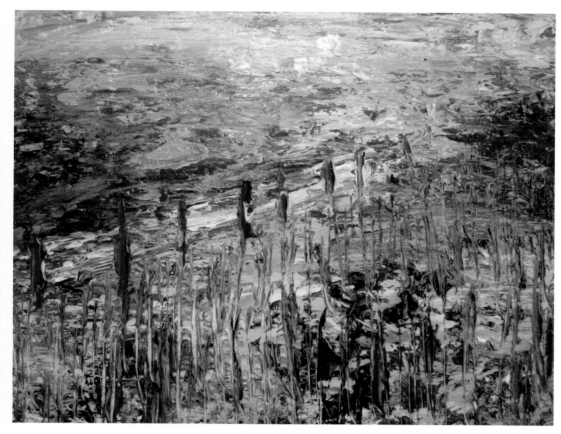

morning dew
little spider
fished all night
and caught only diamonds

Ed Marshall

The Fence Line, Oil on Canvas, 20x24, 2004

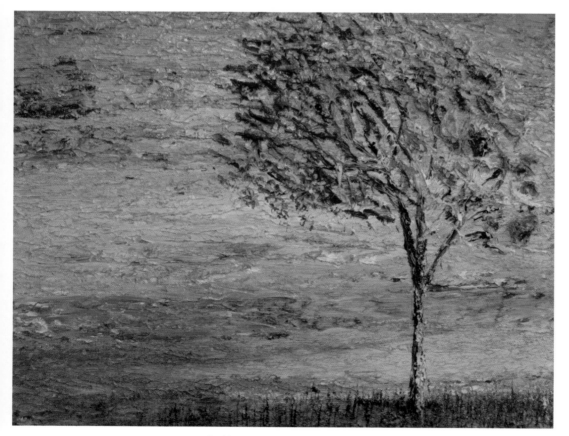

Within the earth,
wood grows:
The image of
pushing upward.
Thus the superior
man of devoted
character
Heaps up small
things
In order to achieve
something high and
great.

Hexagram 46,
Pushing Upward, I-
Ching, translated by
Richard Wilhelm

Tree of Life, Oil on Canvas, 20x24, 2004

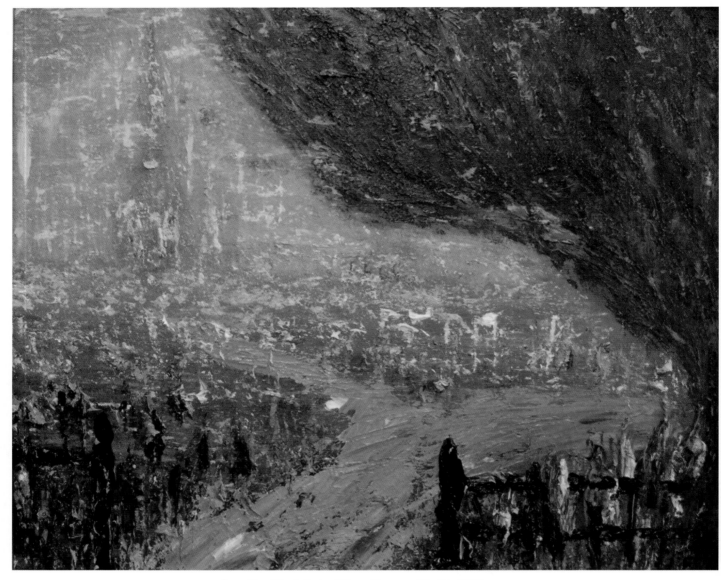

The Final Gate, Oil on Canvas, 20x24, 2004

This painting precipitates reactions. Some people love it and others dislike it. My work discovers balance. The ominous, nearly gory gate is powerful and bold. Beyond the gate is simple, light and ethereal.

It took me over 12 months to complete this painting—an example of the creative process working its magic in me. From the beginning I knew this was going to be an iterative painting--that is, it was going to take me many, many sessions to finish. It did. When I started, I had a relatively fuzzy image of the composition. I knew there had to be a Cathedral in this painting—but that was all I knew. So I just started painting. That first night after I left it in the studio partially completed and went to bed, I dreamt about it. I got some other ideas for the composition but I still had to leave it incomplete that next evening. Over the next number of months I went on to paint a lot of other paintings. In between other paintings, I would stare at it in the studio. Each time I went back to it, I did some things, looked at it, did some more things, looked at it, still did not feel it was complete, and set it aside again. All along though I knew it was a work in process--I knew it would come together. It did. Perhaps like life itself. The Final Gate.

THE LOOSE ENDS

It is now the end of 2004. I am sitting at my dining table crafting these last sentences before the manuscript flies to Hong Kong for printing. My 14 year-old son is typing his school presentation in the loft above me. The other five children and Judy are out for the next several hours, running errands, visiting friends, living. The house is still but for the tap, tap, tap of our dueling lap-tops—the sounds of modern communication, language creation, echoing off the walls of the living room. I must finish the book—there are some things I failed to share.

The airplane is still locked inside somewhere. I have made three attempts, and achieved three failures. For some reason, the original vision that started this journey is refusing to translate to canvas. Writing this book has caused some recent, intense visions of the airplane. I have been so busy writing that I haven't painted for several months. Maybe when I quit writing, it will come. Maybe the Angel of Flight never will come. One thing is for certain, I can't control it. More importantly, I have learned something, which may have been one of the lessons of my journey—I am accepting and peaceful with not controlling it. When the airplane is ready for birth, it will fly forth like my other paintings.

I haven't had any other dangerous incidents in letting the artist out of the house—and I don't anticipate I will. Getting deep into either brain is a choice—nothing pushes us there. I don't let myself go there when I shouldn't.

Perhaps to make one of the messages of this book more poignant—that none of us have a promise of more life, that all of us have limited time to find our gifts and give them—Uncle Dick died in April 2004. Over the three years I knew him, I only spent the equivalent of seven full days with him over four visits. Perhaps that number is meaningful. Those seven days were amazing. They were filled with art lessons, laughter, good food, art shows, music, light, color, and unending conversation. In between visits, we wrote to each other and spoke on the telephone occasionally. When he died, I had just gone through a busy time with both my work and art; so, I hadn't told him about being juried into the second gallery. I was juried in a couple of weeks before he died. I had to tell him at his funeral, with tears streaming down my face. I felt badly for not having told him in person, he had been so proud of my accomplishments already.

Since his death, so many other things have happened with my art, but I keep him informed. He is with me in the studio. He willed all of his art supplies to me—all of his paints, books, brushes, palette knifes, and supplies. Uncle Dick is with me, physically and spiritually.

At his funeral, I expounded on the genius of the man. Richard Hill Chase never took the time or effort to put his art out into the world. His genius, his calling, his gift to the world was in teaching. He knew I was his last art student. He had been retired for nearly 10 years by the time I had the honor of entering his tutelage. I am well aware that the only reason I had that chance is because Judy and Uncle Dick were best friends—although Uncle Dick and I bonded instantly. So, perhaps it was the connection between the three of us that made it magical. Or perhaps it was because I was his last art student, and he knew he had one final chance to make another mark,

that I got the benefit of all 70 plus years of his wisdom. Or perhaps it was something else I have yet to understand.

The reaction I received from my friends and family reading the draft manuscript of this book was, "In person, you seem like a confident person. I had no idea this was going on for you—that you had such feelings of self doubt." That was followed by, "And along with some crude language you used in the text—are you sure this is the impression you want to give to people of who you are? It doesn't seem to fit the articulate business person we know." When we push ourselves to see new vistas in life we become more vulnerable. For me, this opened up a place inside that seemed guttural, young and unpolished. Therefore, I felt the language I chose was important in communicating the level of feelings I experienced in this journey. I certainly hope I did not offend anyone—that was not my intention.

It is not easy to admit the feelings of self-doubt that creep up in us. We all feel them—but we don't often acknowledge them aloud. So, part of the message of the book is that we can move beyond those feelings and shine a wider, brighter beam of light. My artist and accountant are reasonably well integrated today—there isn't as much banter going on anymore, though it still exists. I do my best to seek the ever-elusive balance.

Where will the future lead me? Where will it lead you? I guess nobody knows … but I am quite certain I will be painting. I feel like I tapped into an oil geyser—ever ready to spew forth an essential element of life on this planet. In my case, I don't know what the element is, but…it is what it is.

Wherever you are in your journey, I would enjoy hearing from you. I shared my thoughts through this book in hopes that you may find in it some solace, inspiration, kinship, love, perspective shift, connection, empathy, light, creative spark, friendship, or other magic. If you wish, share back with me. Visit my Web site at www.pinktomatoes.com and write in my guestbook—where everyone can see your thoughts. You aren't alone. A simple conversation can lead to …

In this spirit I leave you with a quote from Ralph Waldo Emerson, and wish you the best of luck in all your endeavors.

If we consider what happens in conversation, in reveries, in remorse, in times of passion, in surprises, in the instructions of dreams, wherein often we see ourselves in masquerade, — the droll disguises only magnifying and enhancing a real element, and forcing it on our distinct notice, — we shall catch many hints that will broaden and lighten into knowledge of the secret of nature.

ESSAY IX *The Over-Soul, Ralph Waldo Emerson*